D.A.P.
Distributed Art Publishers, Inc.
155 Avenue Of The Americas
Second Floor
New York, N.Y. 10013-1507
Phone: 212-627-1999
Fax: 212-627-9484

dolorès marat
edges

© 1995: Dolorès Marat pour les photographies, Pascal Bonafoux pour le texte, Marval pour le livre.
Édition française: Marval, ISBN 2-86234-113-4. English Edition: Dewi Lewis Publishing, ISBN 1-899235-15-9
German Edition: Braus, ISBN 3-89466-147-X

text by
pascal bonafoux
translated by Alison Hirst

dolrès marat
edges

DEWI LEWIS

PUBLISHING

there is...

There's a hopscotch game for hopping from ground to sky through dust and puddles.
There are, in a pile on a sofa, magazines and journals squeezed against an armrest. And the smile of a woman on one. There's no one reading or leafing through these relegated, forgotten pages which mean nothing any more.
There's a cactus in rue Véronèse.
There's a cactus still standing like a trident in a desert bordered by a horizon of eroded stumps on a café wall. Balanced on it a triangular lamp eclipses the redness of a washed-out twilight sun. And the shadow stretching out, shifting, takes no account of either the painted sun or the bulb of the shining lamp.
There's the Mona Lisa smiling between the strips of wallpaper, hanging on a hook between the drab bouquets and garlands.
There's an ashtray placed in the middle of a café table in the red light. No one is sitting at the table. No one has stubbed out a cigarette in this ashtray.
There's a carpet hanging. A hanging carpet which someone will have beaten.
There's a television placed in front of ceramic tiles. A switched off television. The reflections of lamps on the screen. No one is watching this television.
There's a bald mannequin. Without a hand. The bust is

placed on the legs. Out of line. Horizontal, a line like a clean
razor slash. Perpendicular, a line splits the pubis like a scar.
There are, lined up one above the other, lift buttons. No one
is stretching out their hand towards the second basement
button or the seventh floor one.
There's a table wedged against a wall. On either side
of the table, chairs with orange upholstery. These
metal chairs, like the table, like the geometric
wallpaper pattern, must date from the sixties.
A serviette, spread out diagonally on the table, instead
of a table-mat. Placed there, a pot for a wilting plant.
Perhaps no one has watered that plant for years.
Perhaps not since the sixties.
There are, somewhere else, along a wall, two chairs made
of badly matched wood. Empty corridor.
There's a billiard table in the weak light of a lamp. No one
is playing. No one is walking on the white ceramic floor,
punctuated here and there by black tiles, like an erratic
draughtboard, an incoherent, absurd chessboard.
There's a mannequin's head with closed eyes wrapped in a
sheet of transparent bubble wrap.
There's a staircase plunging towards a light and turning like
someone swaying their hips. Carpet on wooden steps.
The paint is flaking off the walls. Or the walls are peeling.
There's a boiler. Cast iron door like a tombstone.
There's a black dress spread out on the white creased sheets
of a bed. There's a Hoover in a corridor lit by a ceiling light.
Closed doors on the right just as on the left. There's a car
shrouded by a dust sheet.
There's an underground corridor. Wall covered with graffiti,
with names.

There's...There's no one.
There's a park bench at the edge of a path through a square.
And its shadow.
There's...There's no one.
There's a lagoon behind the table of a café. The sea is blue.
The waves break in the distance, probably on reefs. Or lap
the sand, the beach beneath palm trees which the wind
ruffles like feathers. A lamp with its bulb protected by a glass
globe is stuck in the sky, at the end of a thinning cloud.
There's...There's no one.
Deserted places. Abandoned objects. Nothing is of any use
any more. Nothing is of any use to anyone. A sort of
indifference. Or absence. No one.

A tower collapses in dust swollen like foam between poplars
and street lights. No one.
A double door is barred by a chain. No one. Or shadows
going past. Semblances.
These are napes of necks on an escalator. Hair, short,
brown, blonde, long, white. Napes following, going past each
other. Napes which Time is hurrying along. Time for an
appointment, suburban train timetables.
Or this is an old man, behind an escalator banister, hands in
pockets. Looking sadly at...This is an old man going by.
Another escalator. A woman coming down. The fingers of
the gloves held tight in her hands depict the shadow of a
little rabbit on the tiles of the underground escalator. Which
she doesn't see. Which no one sees. She goes by. Indifferent.
Indifference of a young man in Bermuda shorts leaning
against a wall bending over a programme. Just to fool time.
In a room lit by a spotlight hanging from the ceiling a man in

front of a television and tables covered with white table cloths...Immobile. Time stands still in the harsh light.
Behind the window of a cash desk a young woman, eyes downcast.
This is the lost, worried expression of a man, a tumbler in his hand.
And this is the expression of a woman leaning out of a window. To watch time passing. Holiday expression.
And the expression of loneliness. Loneliness of a woman bending over a bag half-open on her knees.
Of a thickset man, limp on a lounger.
Of a man, sitting at the end of a row of empty seats in a cinema.
Loneliness of an accordionist no one is listening to.
Loneliness of a young man resting his elbows on a car, looking into the distance. Where there is nothing to look at. Empty time. Time to fill her up. Time in suspense meaning nothing. Nothing more.
Waiting. A man leaning, his back against a wall. A fag between his lips. Greasy, grey locks of hair. Serious expression. It's too late. Irremediably too late.

There are toys thrown on steps behind the panes of a closed window. Dolls. Litter. Hoops. Buckets. Balls. No one to pick them up. No one to play.
A woman moves forward wearing a white cloak, a snake like a scarf around her neck, and the snake glides over her breasts, flows high up on her thigh at the edge of her costume towards her genitals. She is impassive. Or indifferent. It's too late. No one has anything to do with this fairground snake...

A swimming pool where no one is swimming. A fully clothed
man standing at the edge of the pool. His foot on a barrier.
Waiting. Waiting for what, what can one be waiting for,
dressed at the edge of an empty swimming pool? Nothing.
No one.
A man pushes a door of frosted glass. Solemn face. Or weary.
The side of the double door which stays closed blurs the
outline of his body, his shoulder, the back of his head. It
won't make any difference if he comes through the doorway.
He won't stop being no one. Everything is already settled,
Irremediably.

Fun fairs are nothing but slashes of light.
There are, on all lift doors, painted silhouettes of patient
little girls waiting. And their painted silhouettes are fading,
drowning.
There is, anonymous behind frosted glass, a man in a lift. His
hand resting on the pane in the centre of the door is pushing.
Seems to be pushing the door. This gesture of the hand with
spread fingers is forbidding. There's no one any more.
No one.
Everything is settled. The red curtain is down. There's hardly
anything to read but a sign, NO SMOKING.
There's a hand wearing a transparent plastic glove like those
used in hospitals to put on dressings. To spare oneself: To
keep at a distance.
There is...

There's the portrait of the time of indifference. Helpless,
wasted time. There's no one left to play hopscotch. Dust,
puddles and time have obliterated the sky.

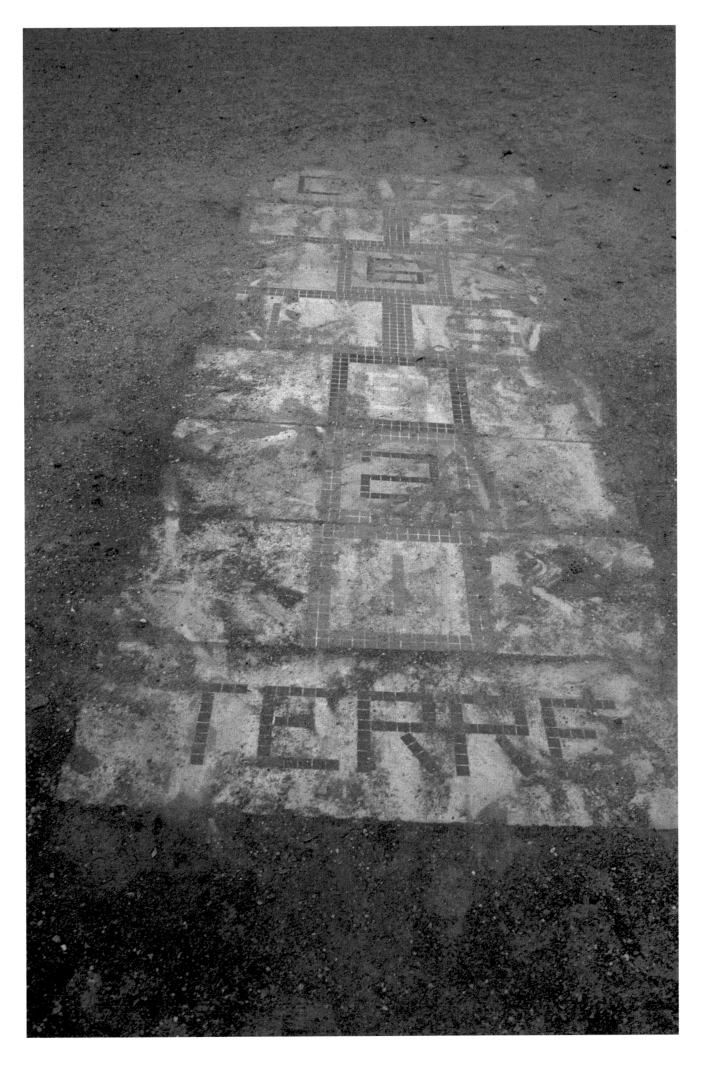

La marelle en
mosaïque, 1991

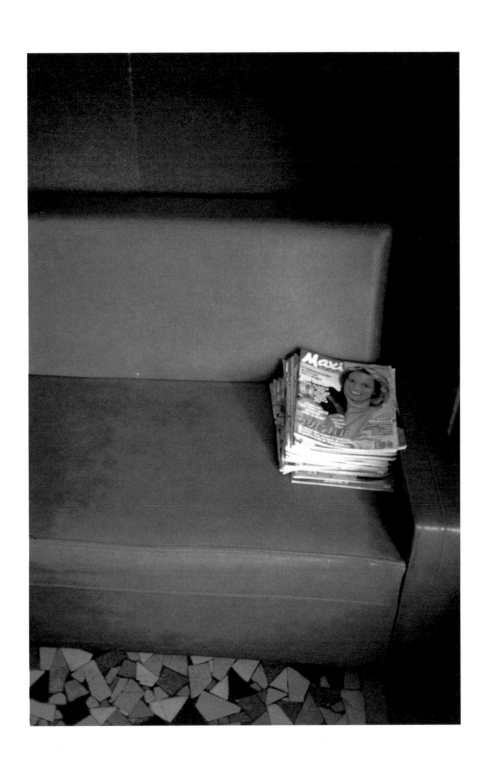

La banquette
de l'hôtel,
1990

2

La fille
qui rit, 1987

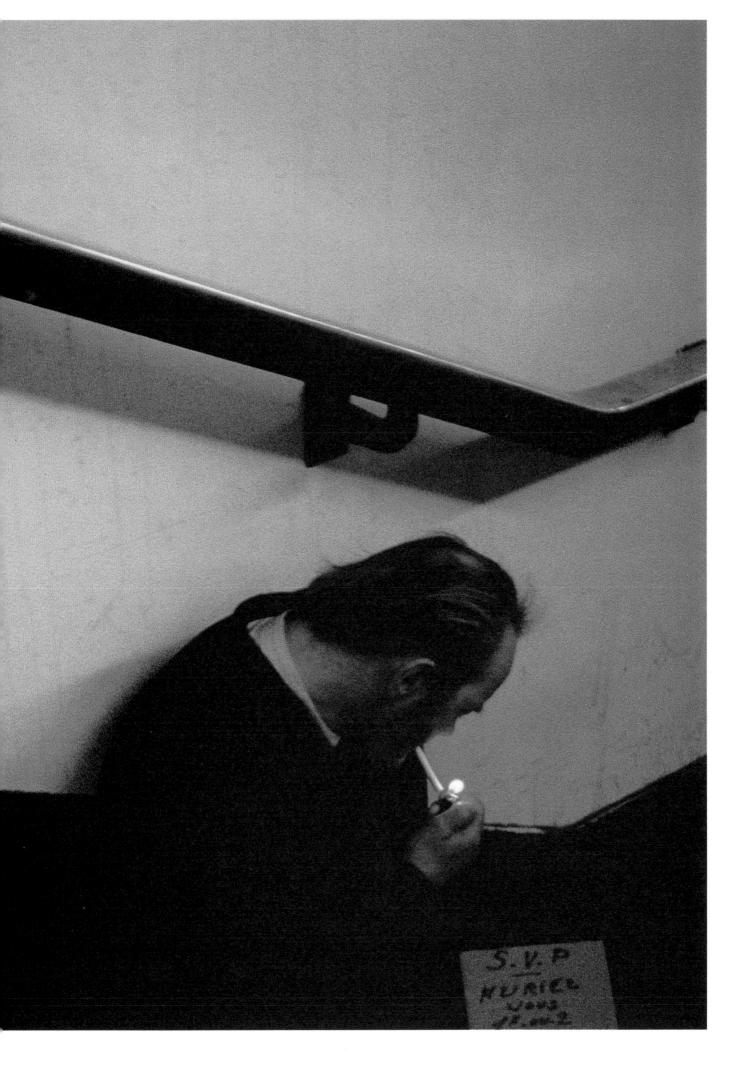

L'homme qui
allume une
cigarette, 1993

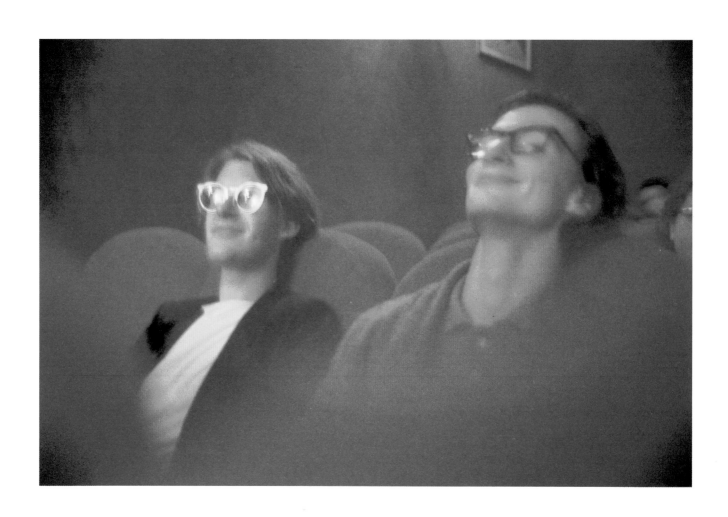

Les deux
spectateurs,
1988

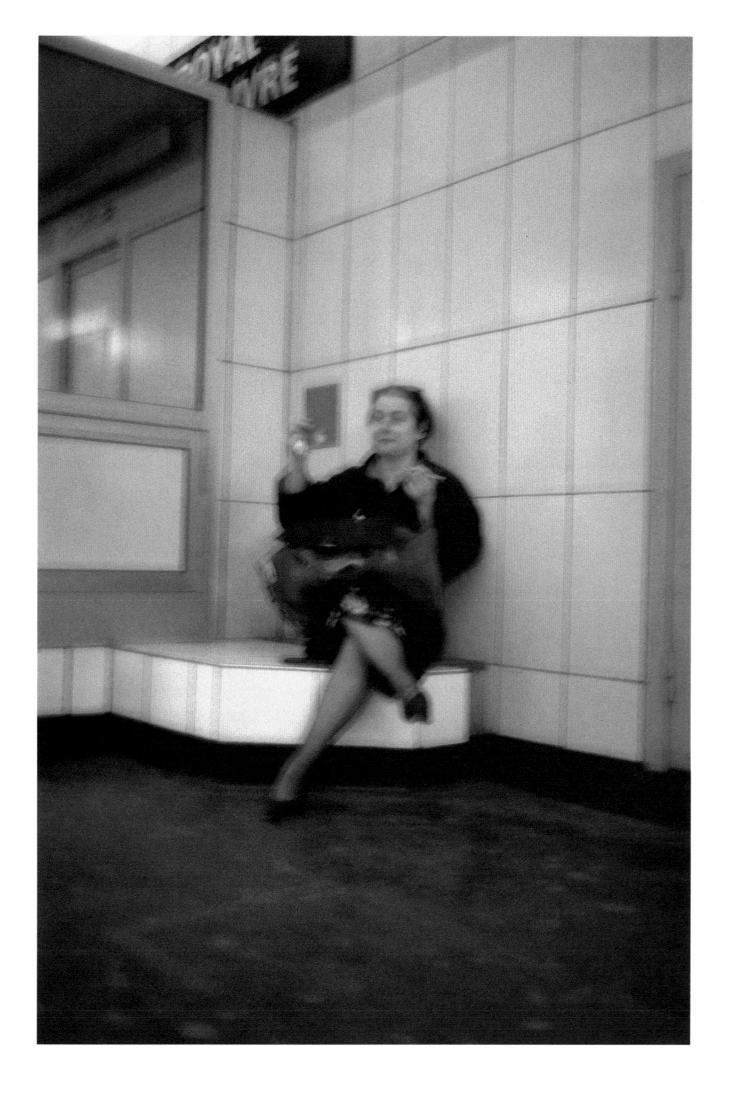

La femme au
miroir, 1993

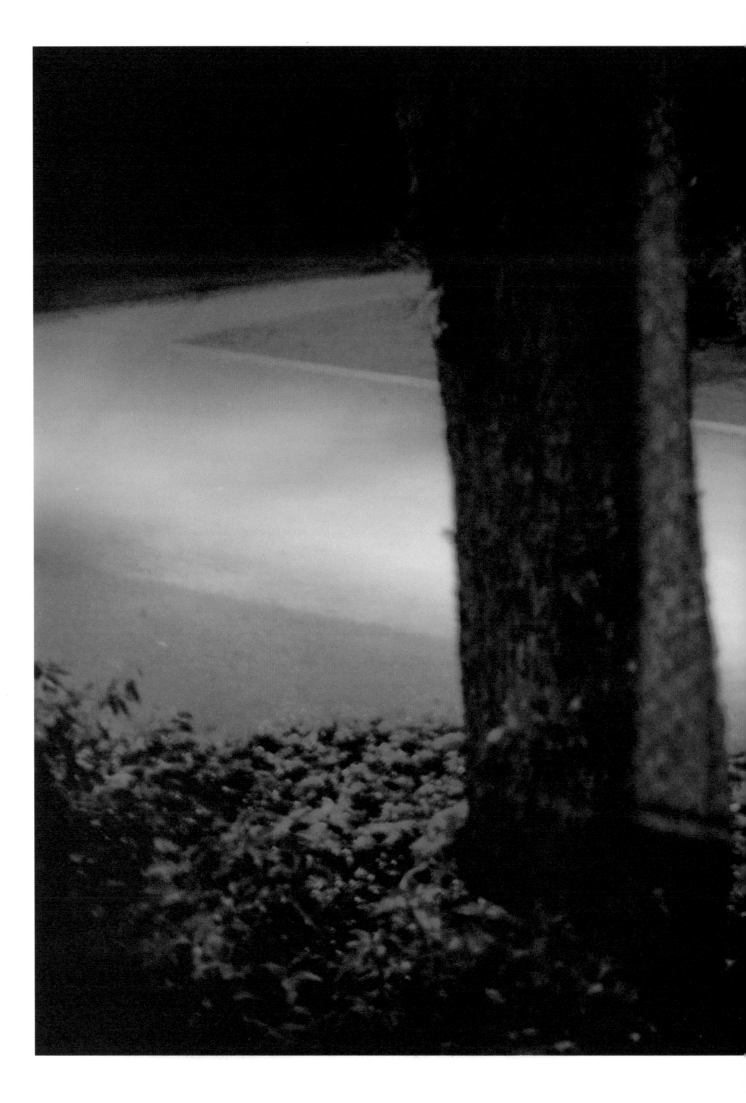

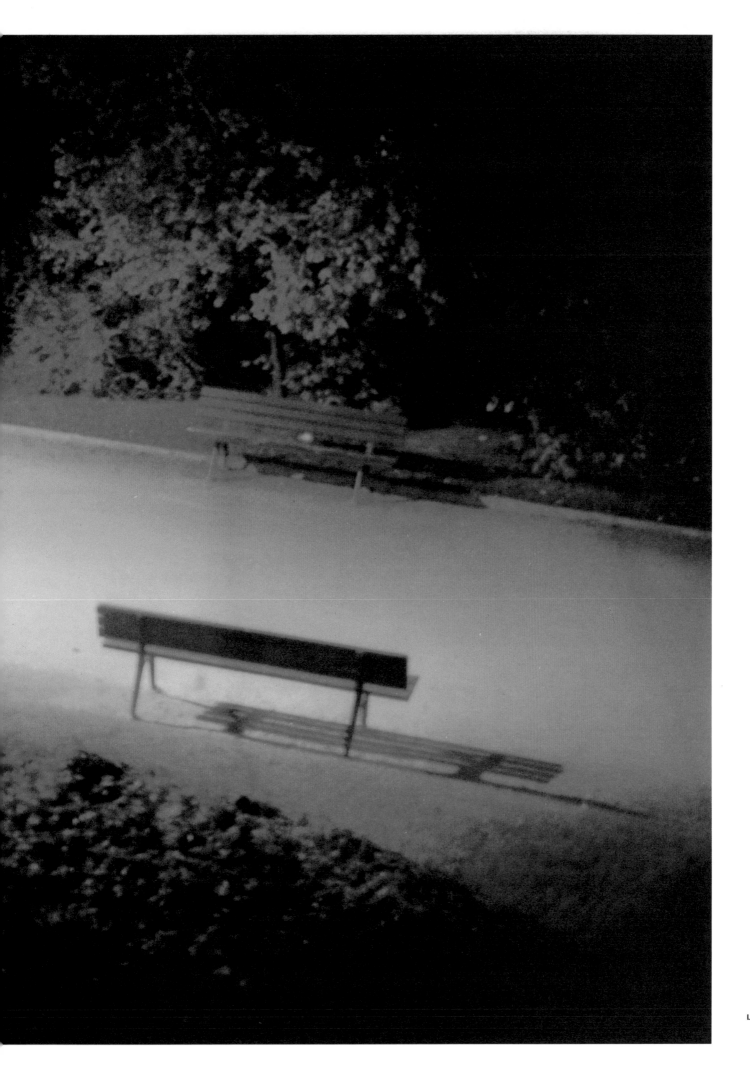

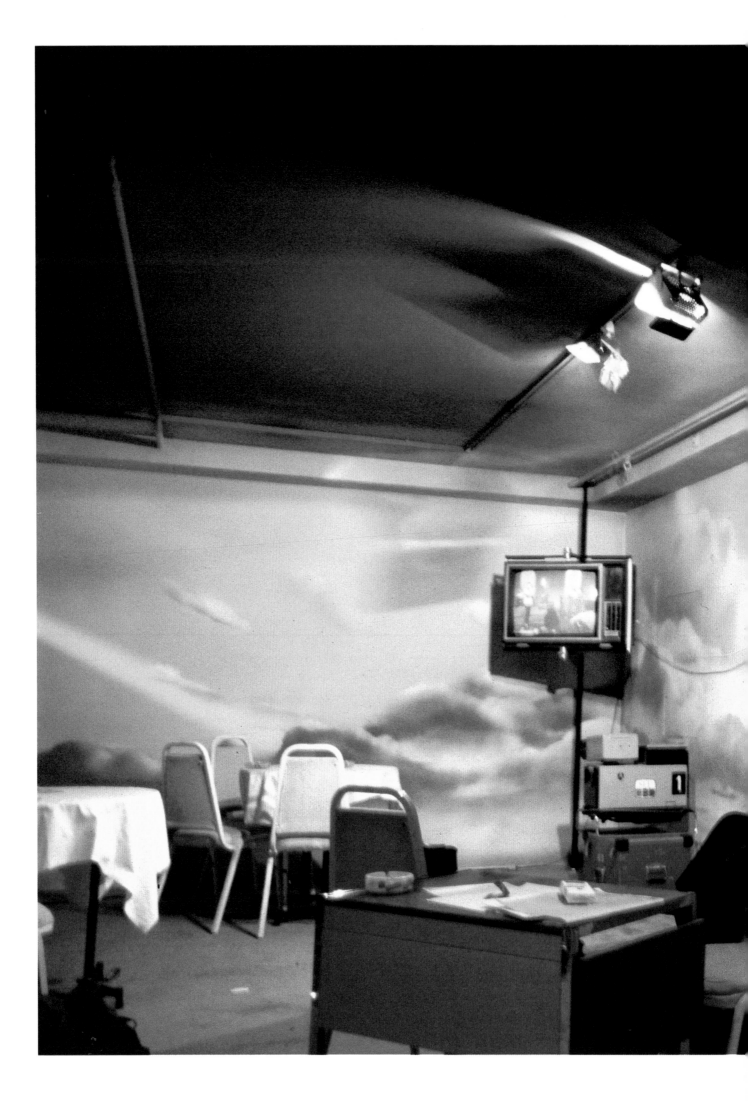

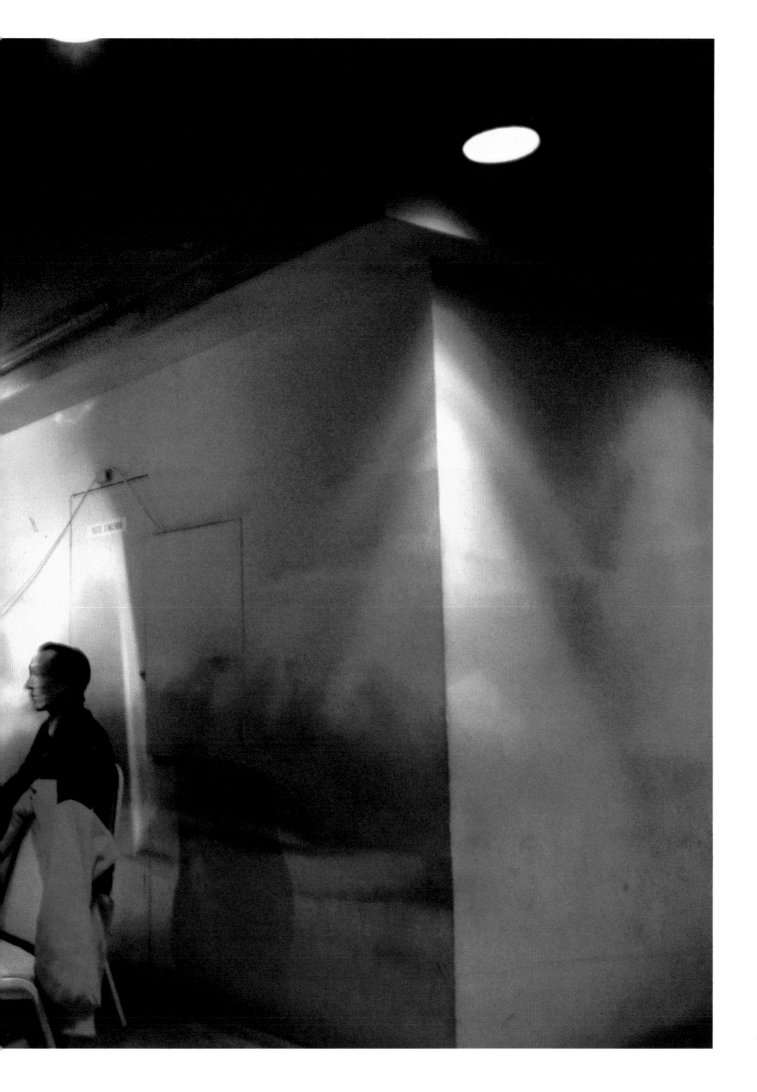

Le gardien
de télé, 1984

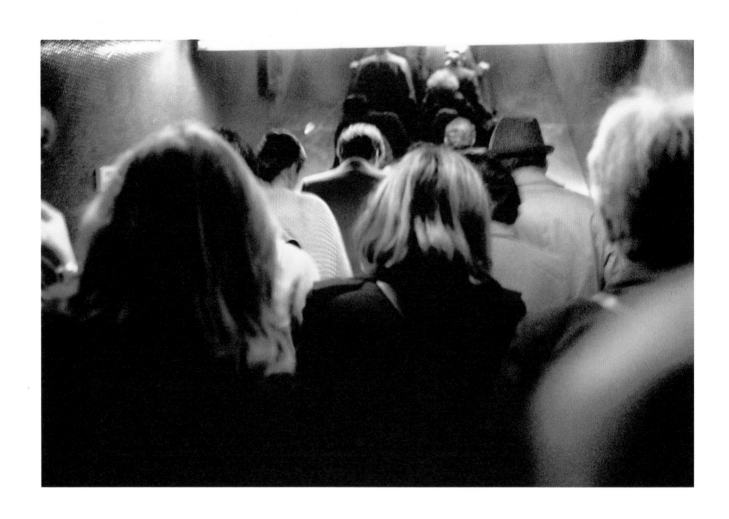

**La foule dans
le métro, 1985**

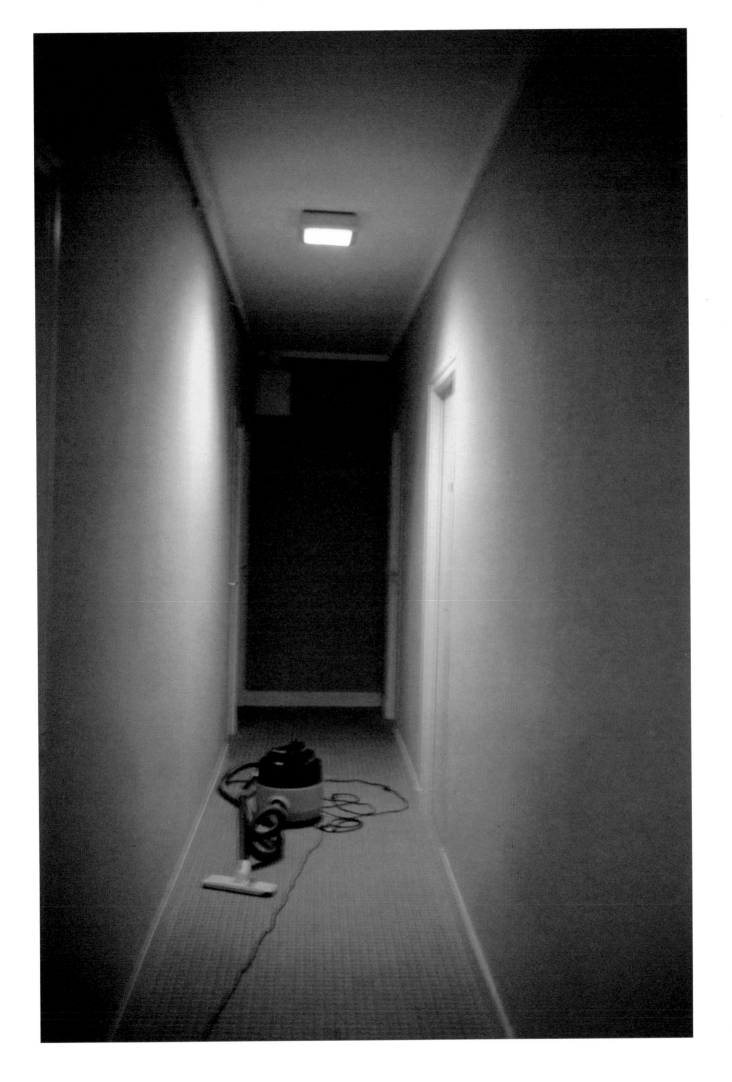

L'hôtel de
la plage, 1986

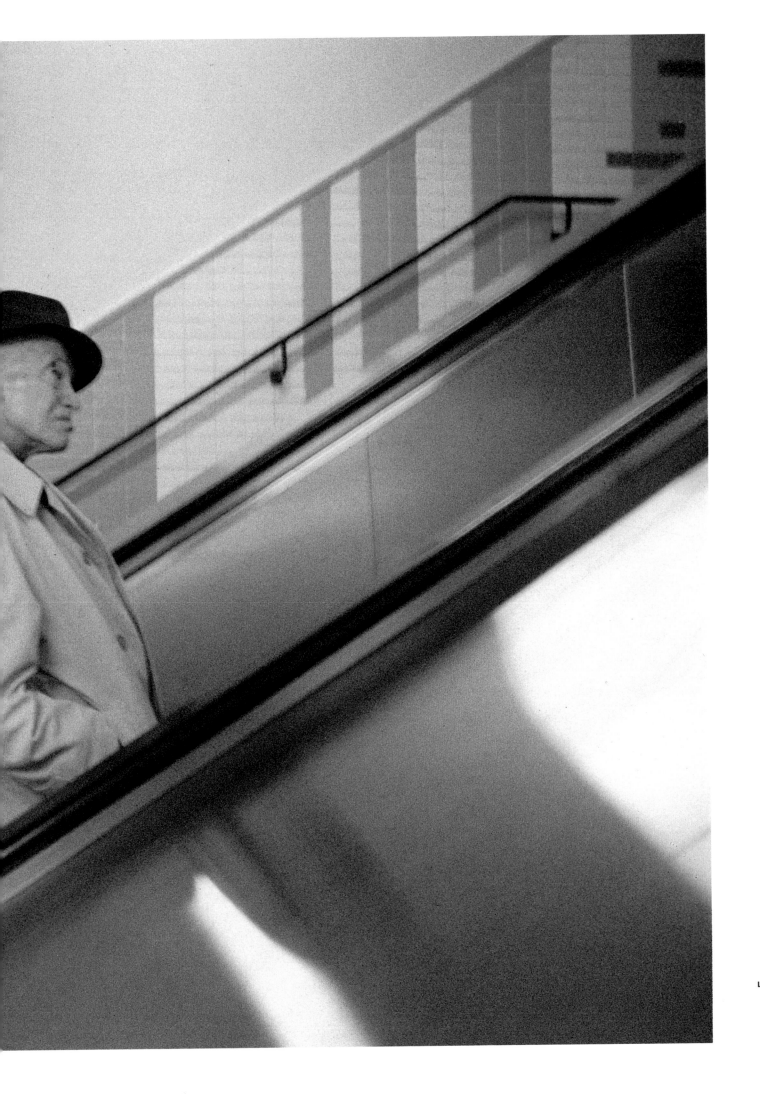

L'homme qui
monte les
escalators,
1994

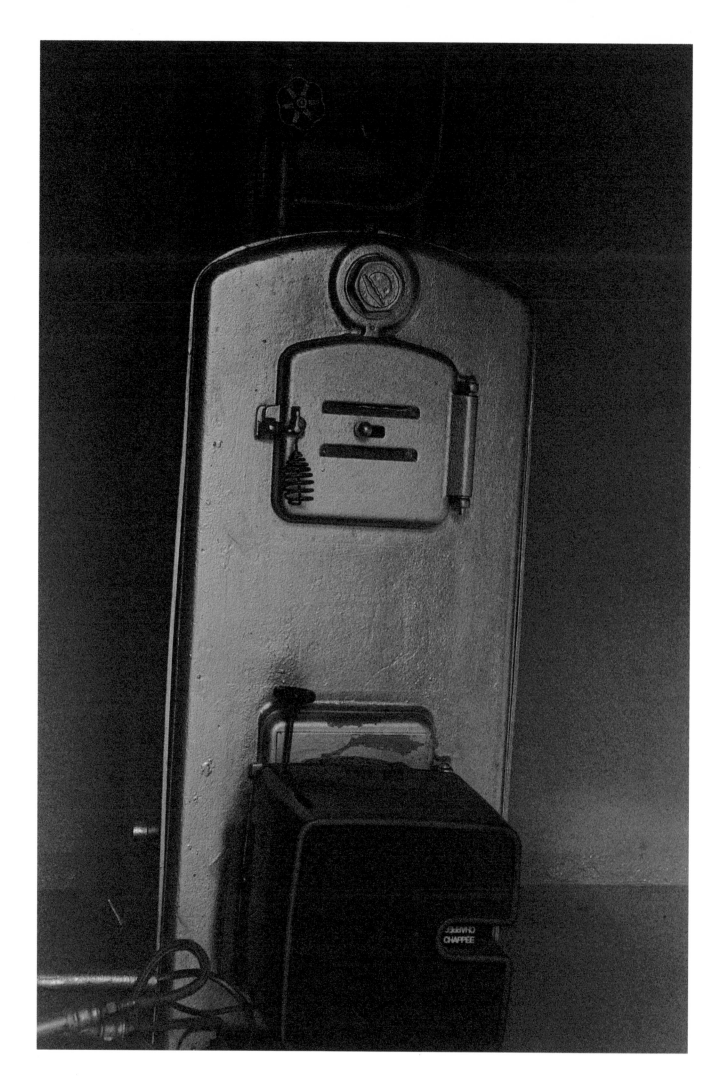

La chaudière
des Mureaux,
1994

12

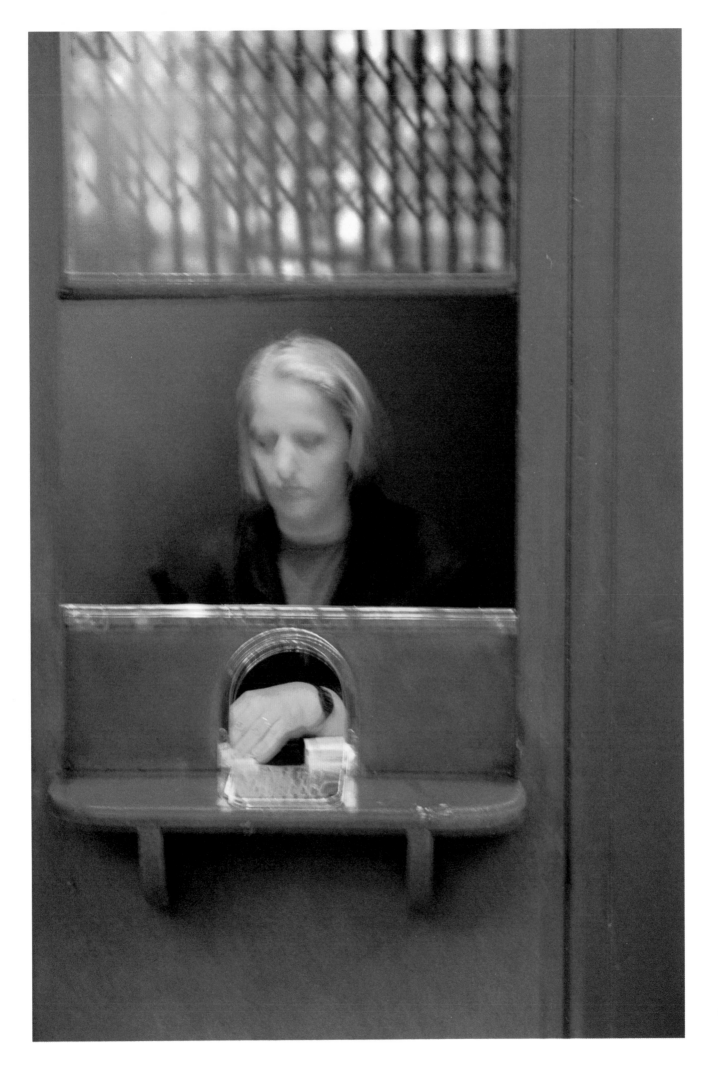

La caissière du
théâtre, 1988

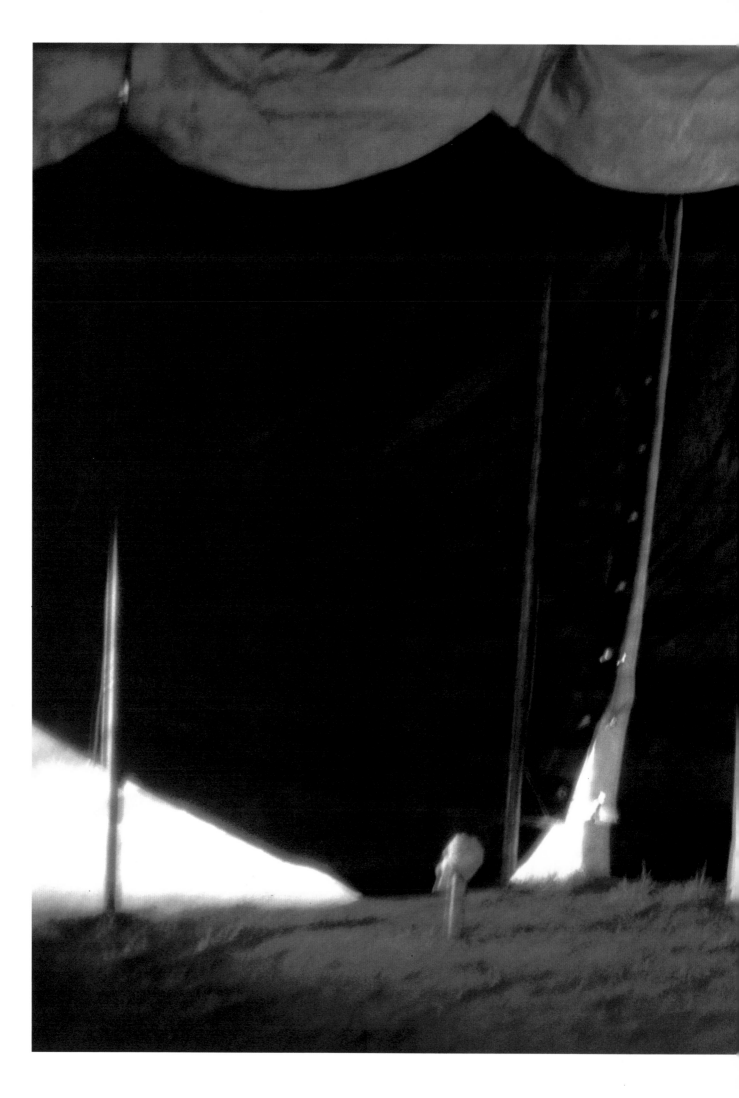

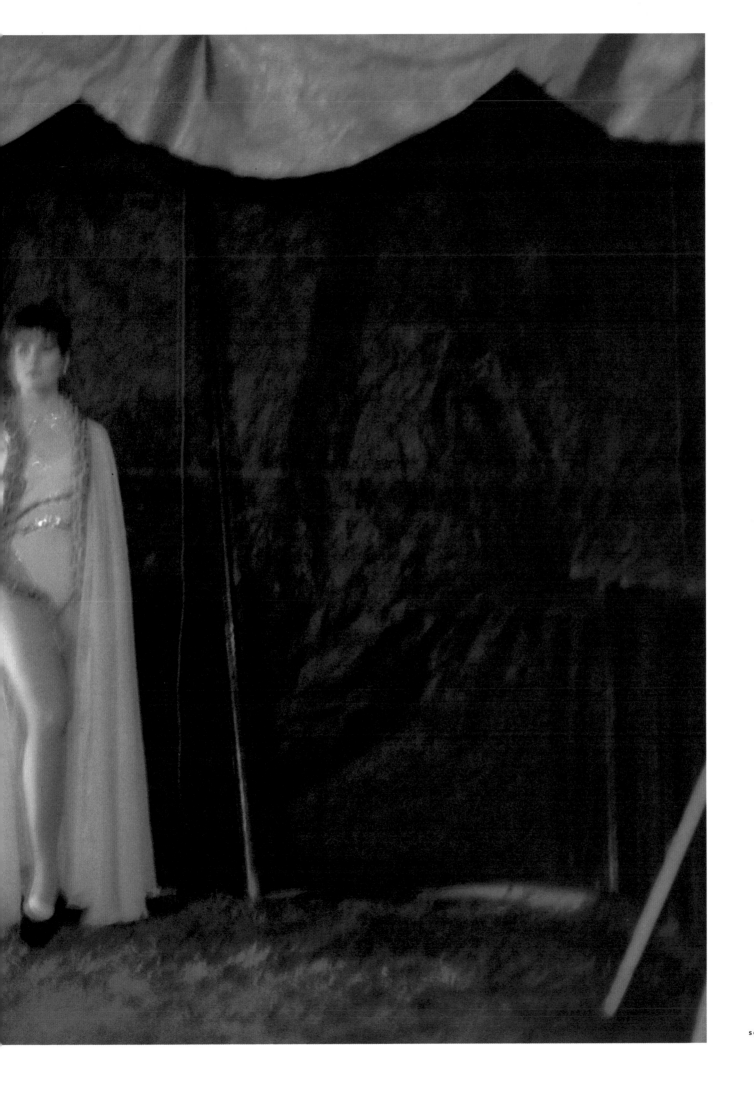

La fille au
serpent, 1989

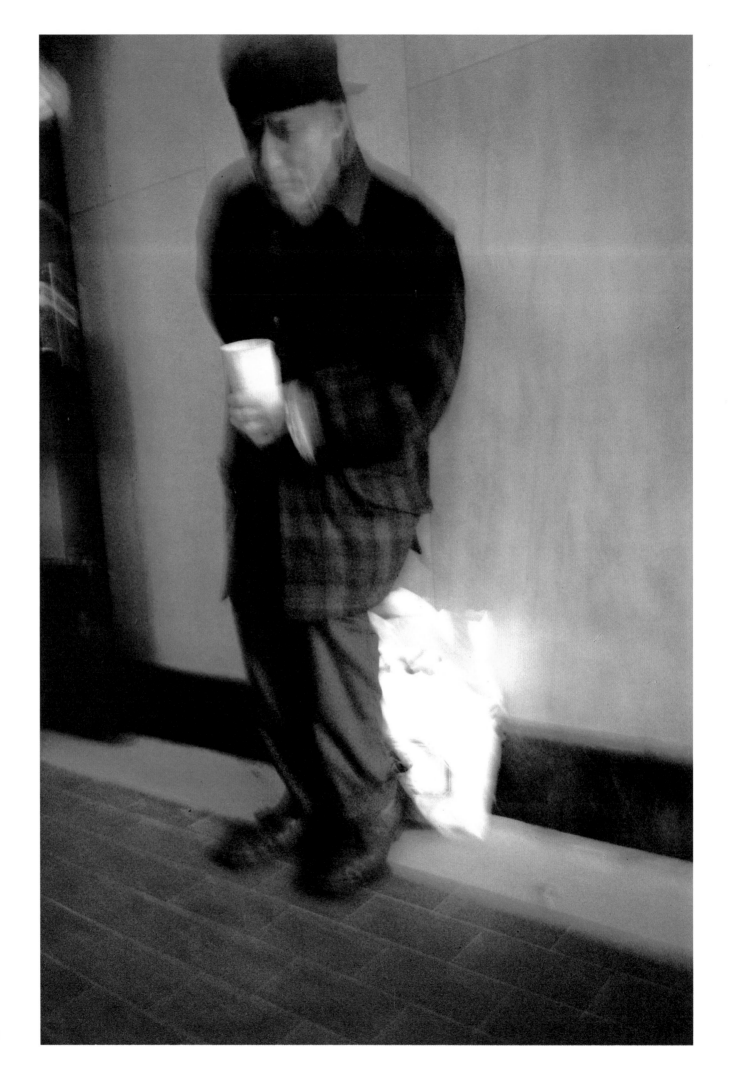

L'homme au
gobelet, 1994

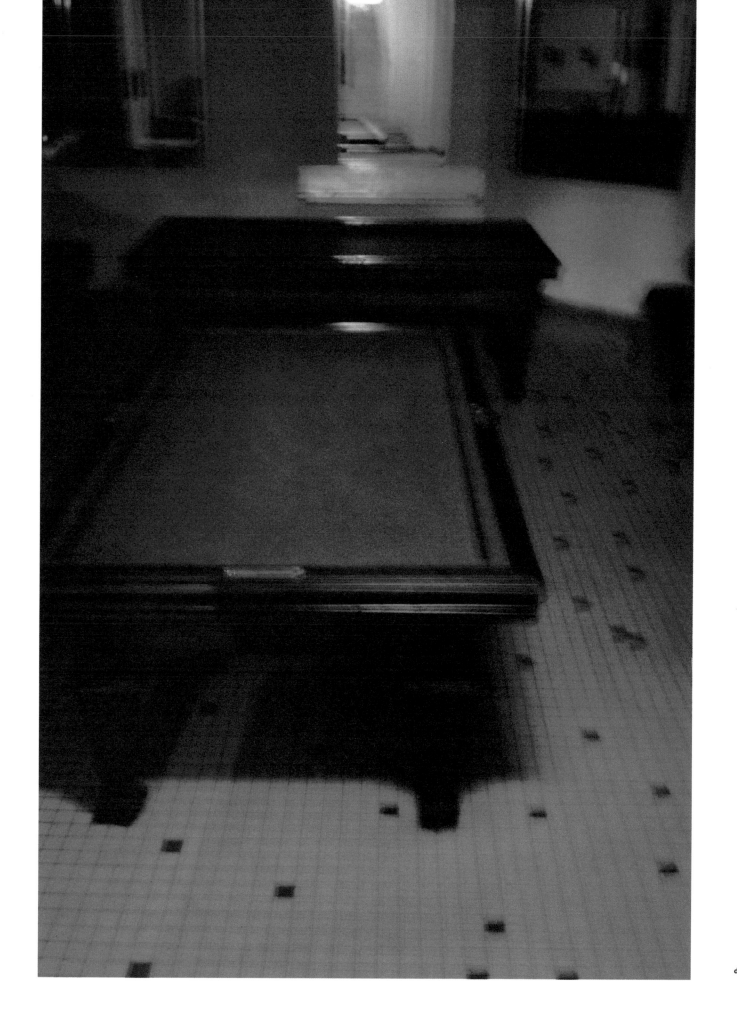

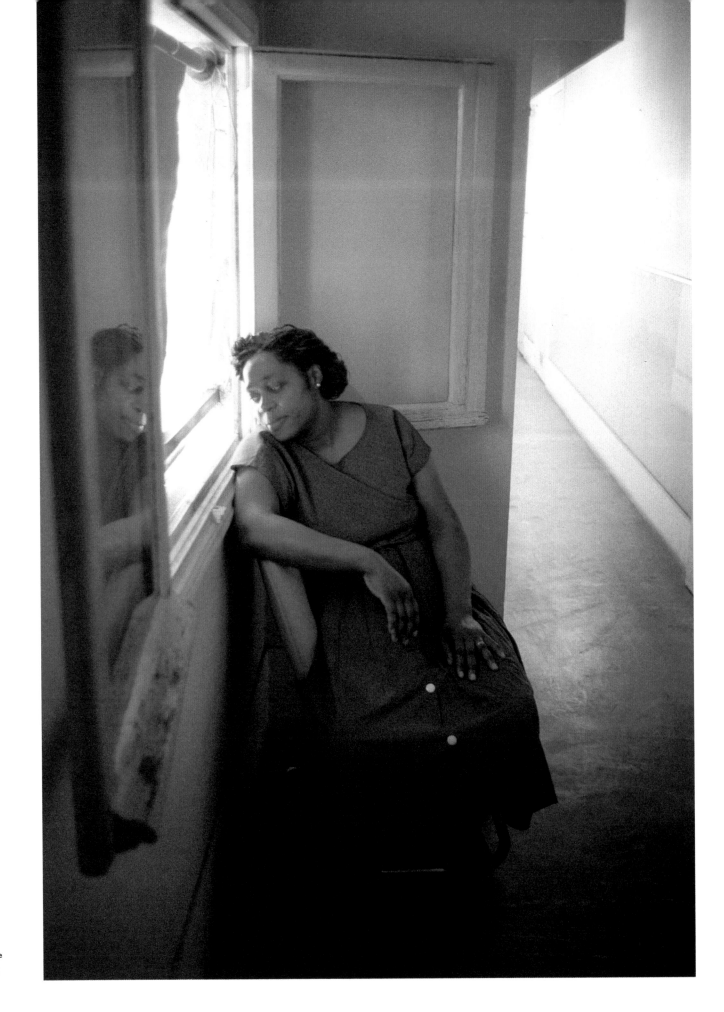

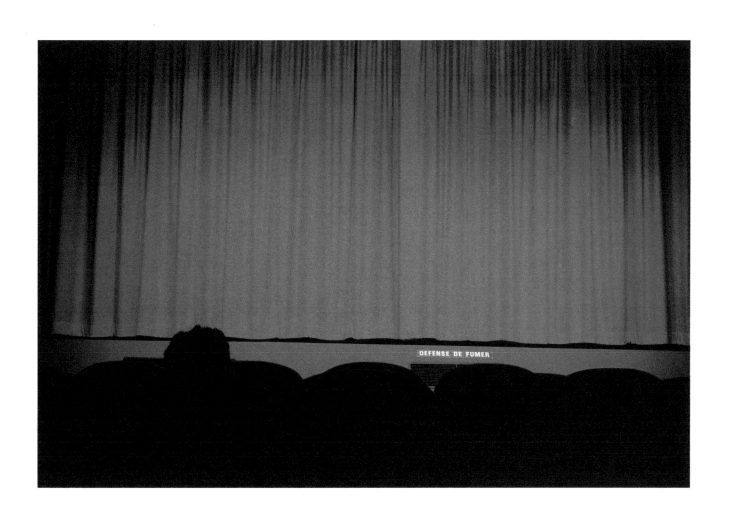

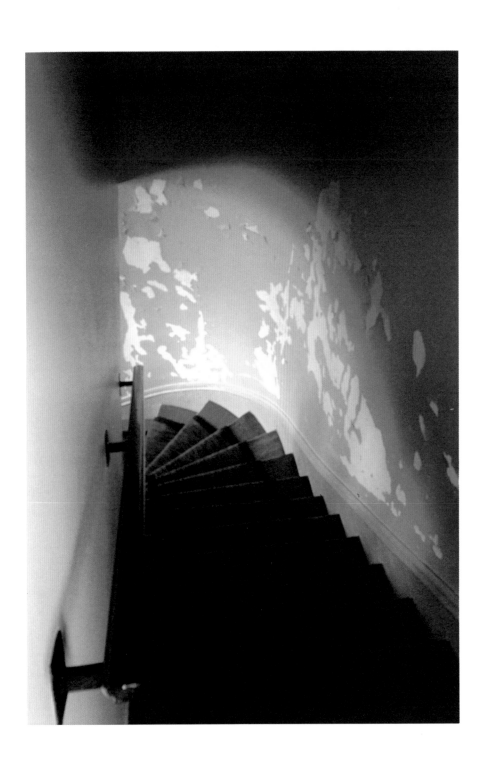

L'escalier rue
Jean Mermoz,
1990

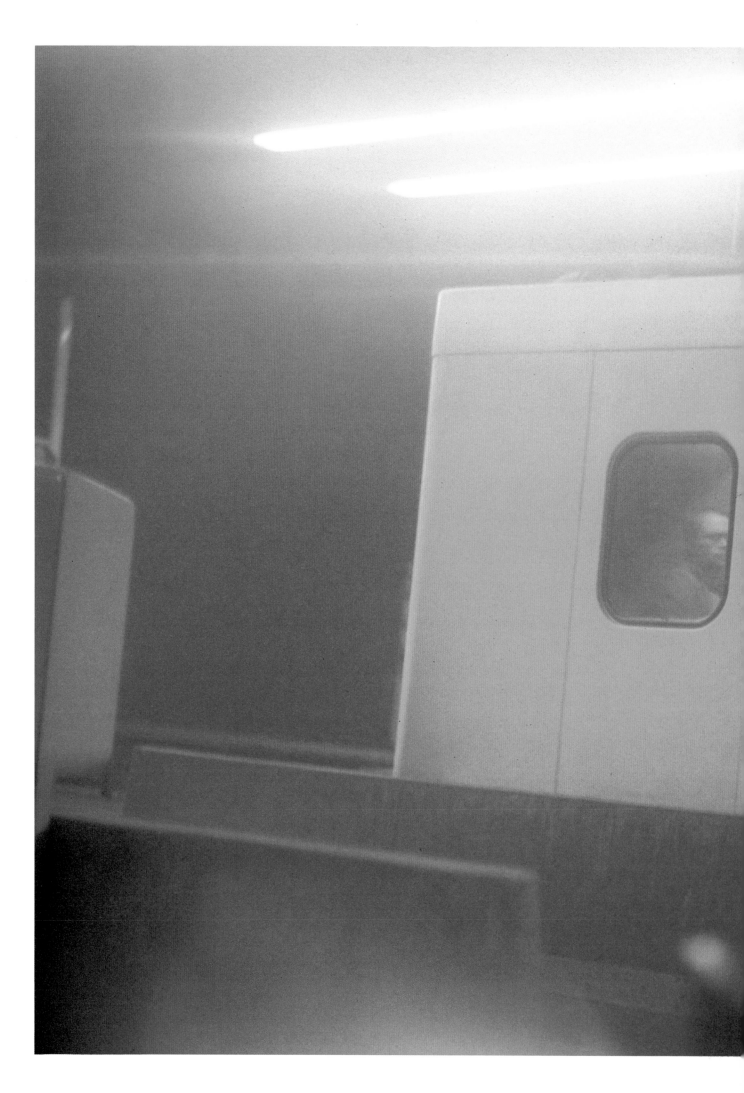

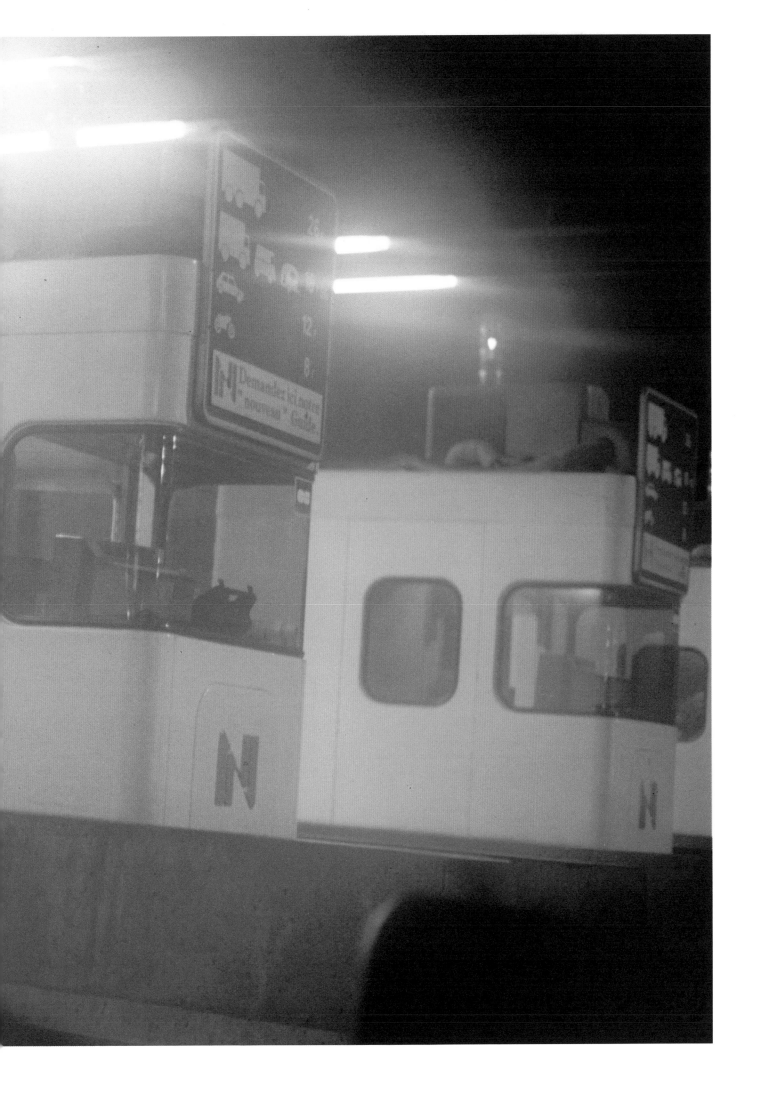

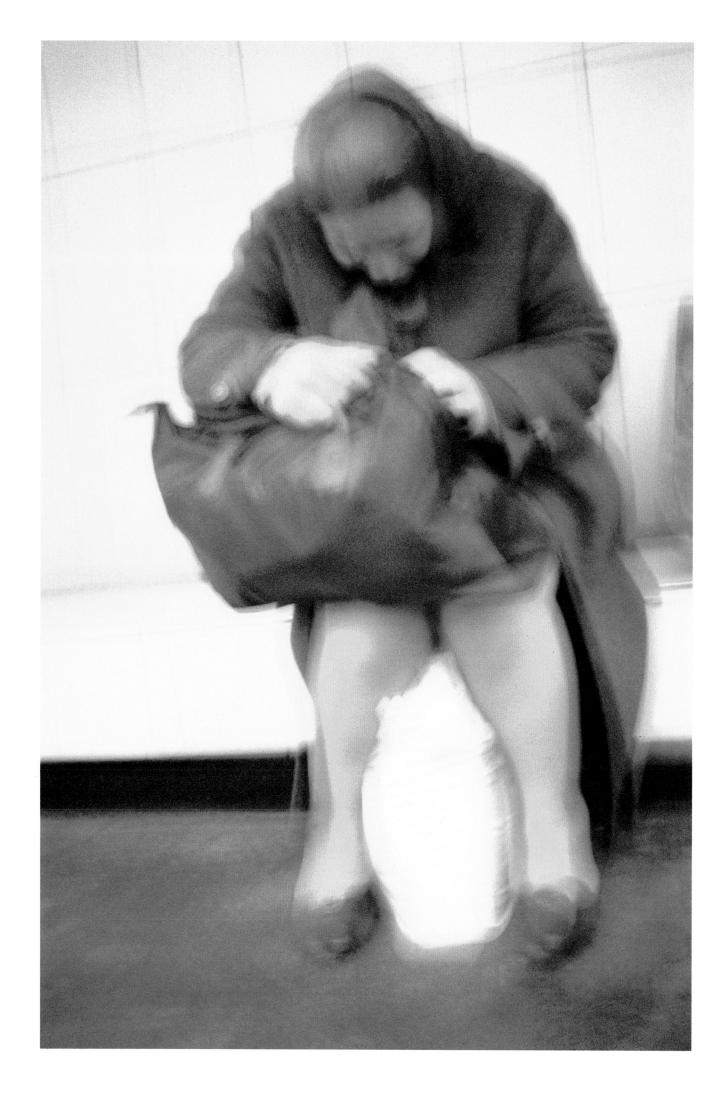

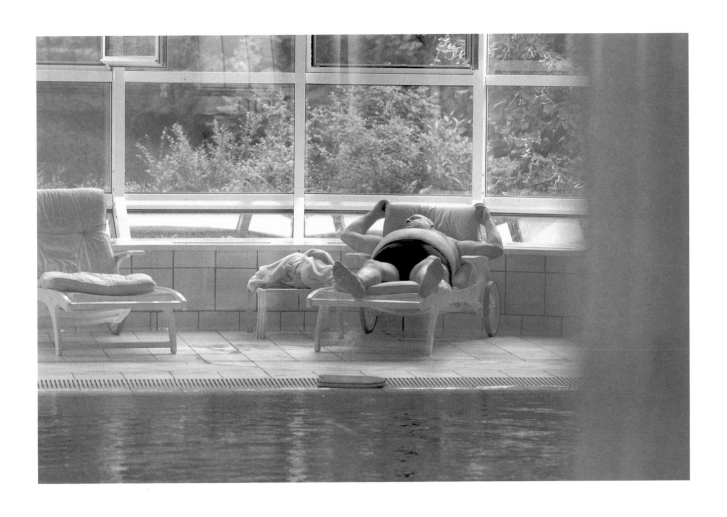

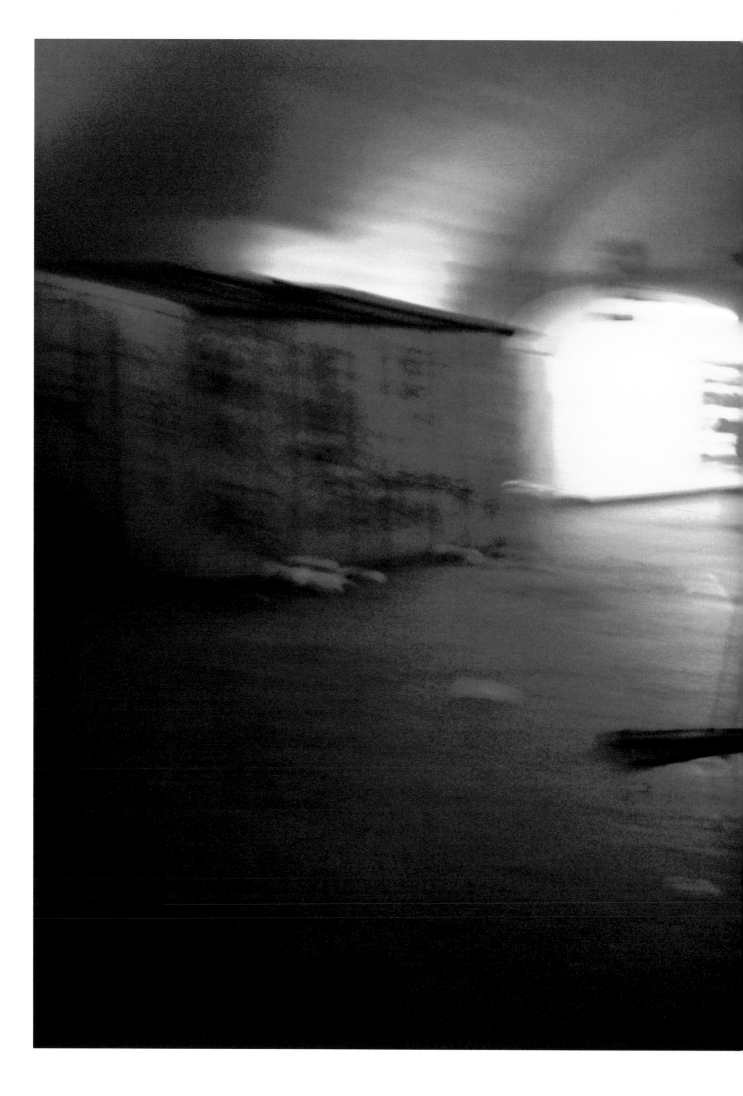

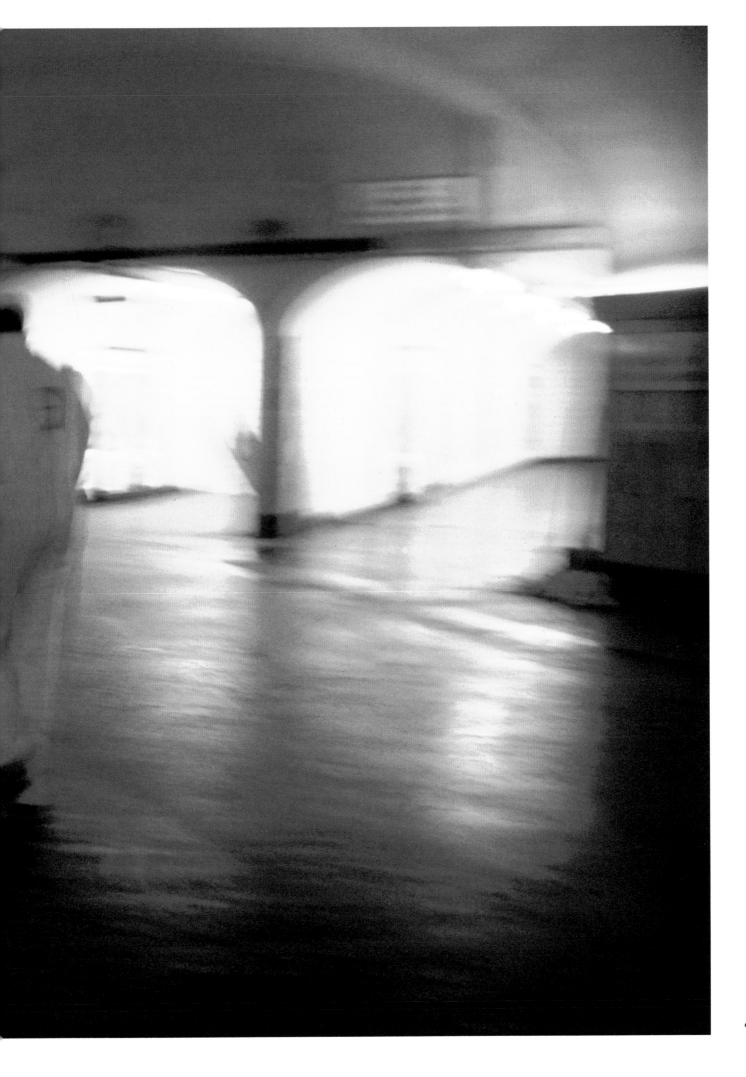

Le balayeur
du métro, 1990

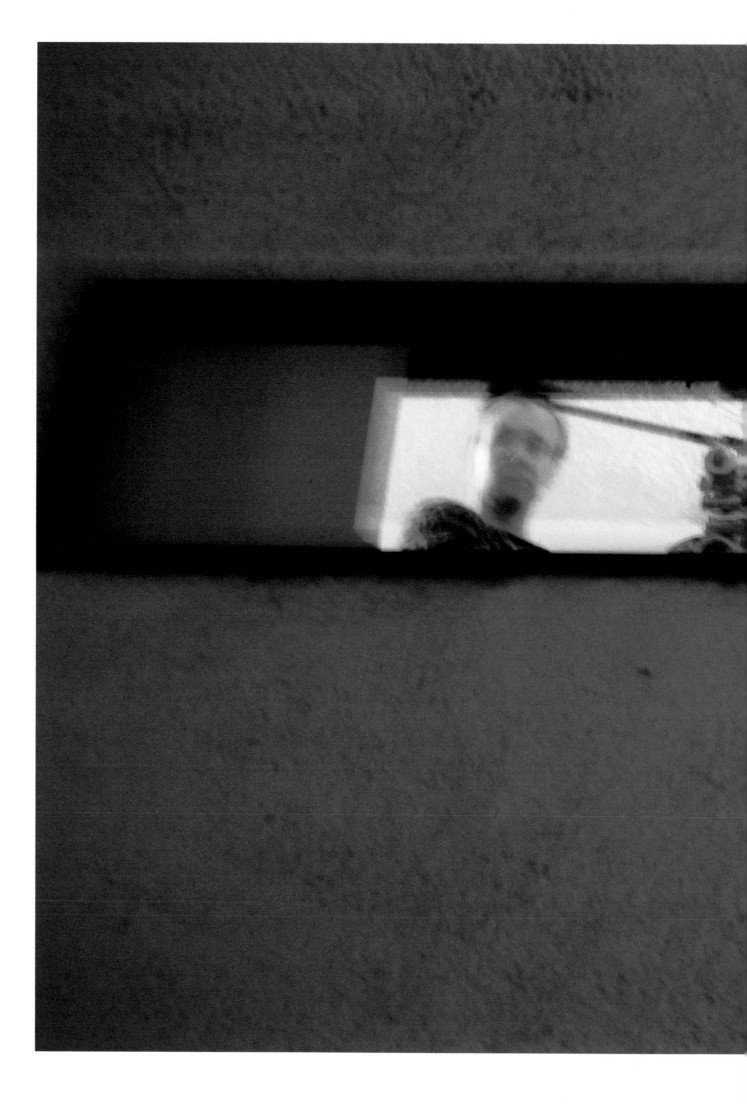

Le
projectionniste
du Fauvette,
1988

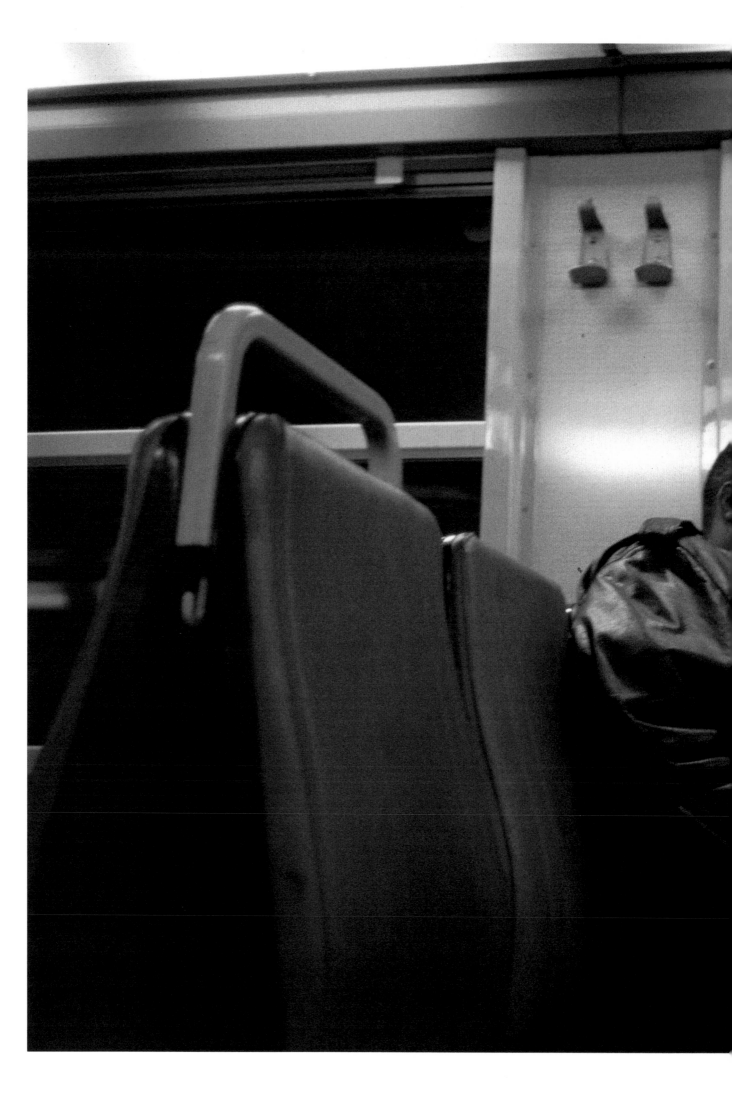

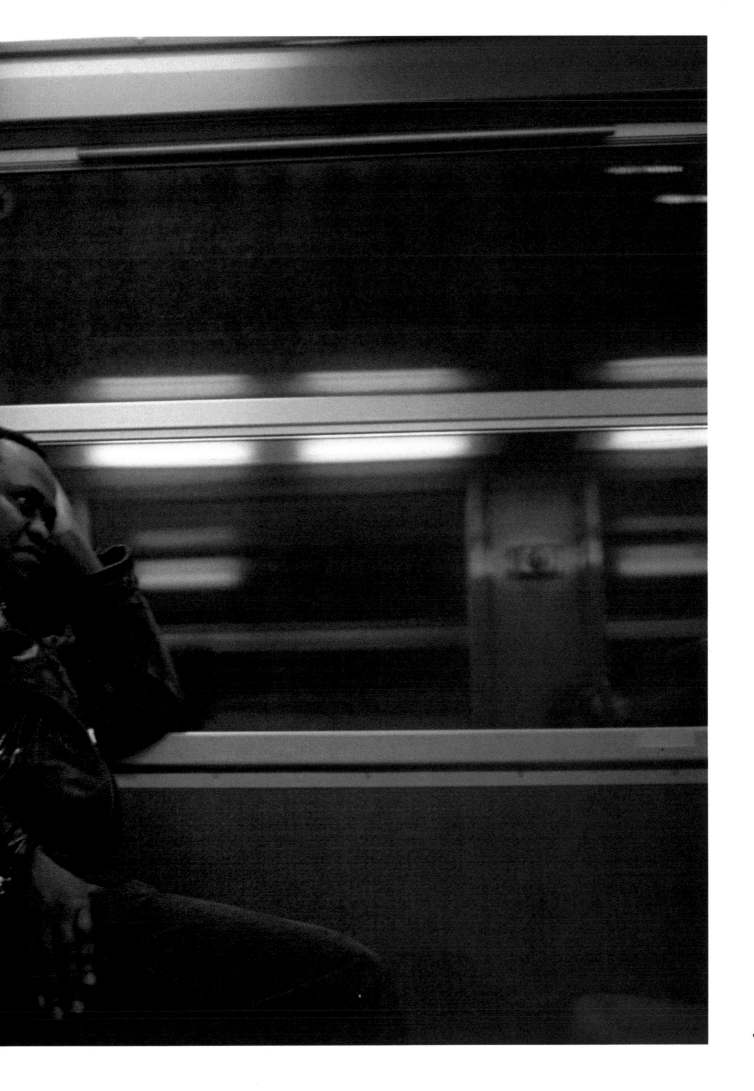

Le voyageur
du RER, 1993

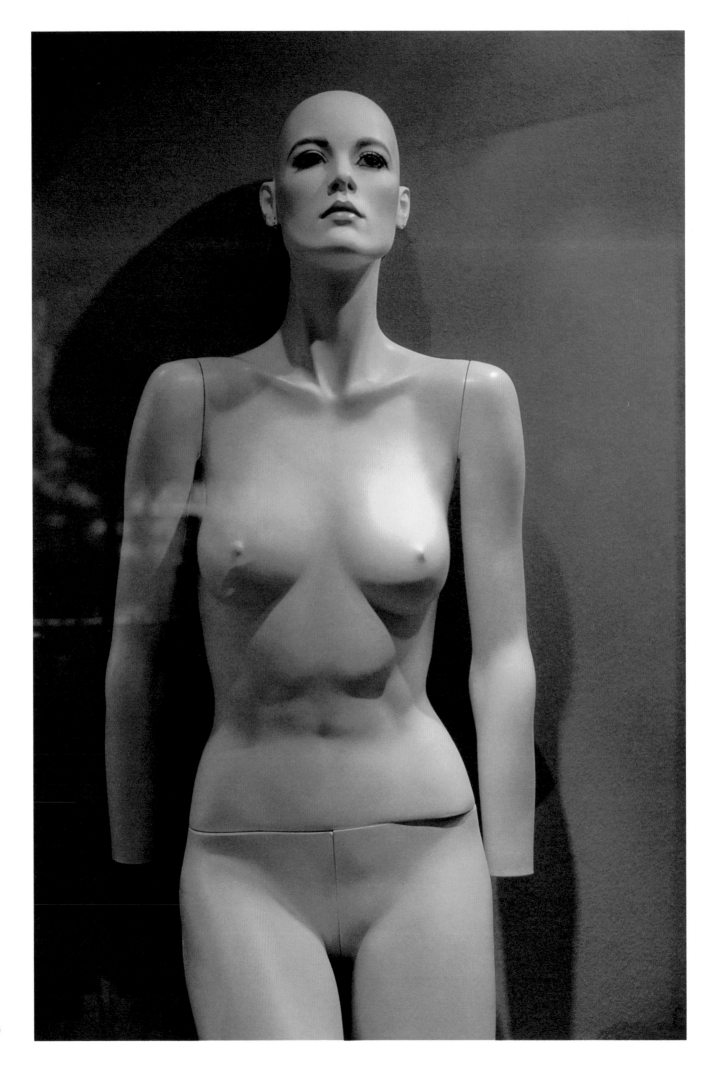

Le mannequin
sans main, 1989

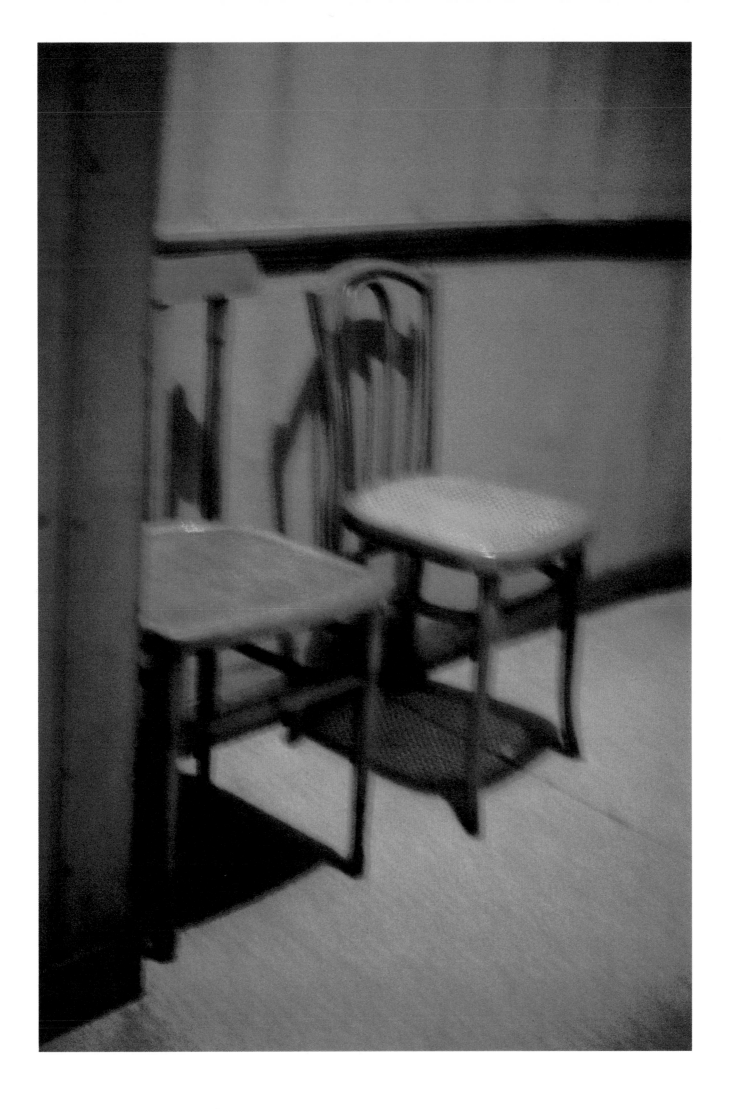

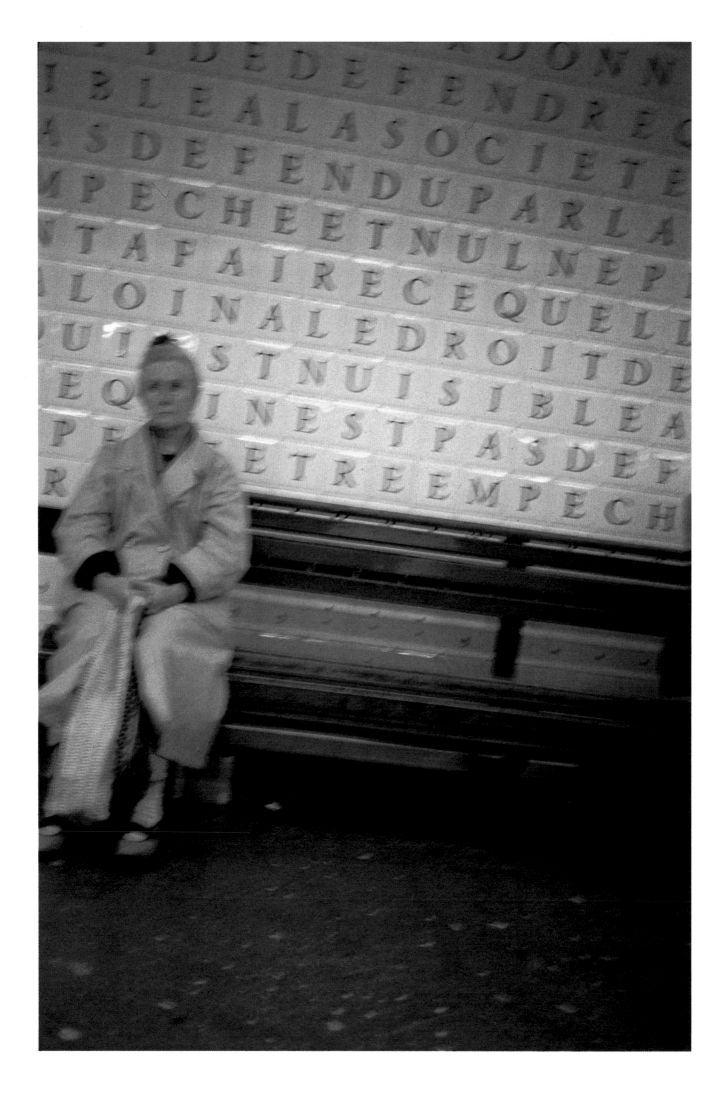

La femme
assise à
Concorde,
1993

28

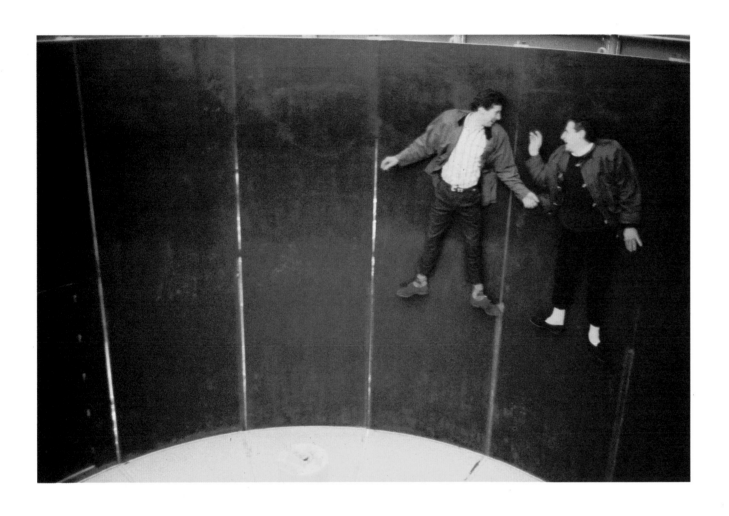

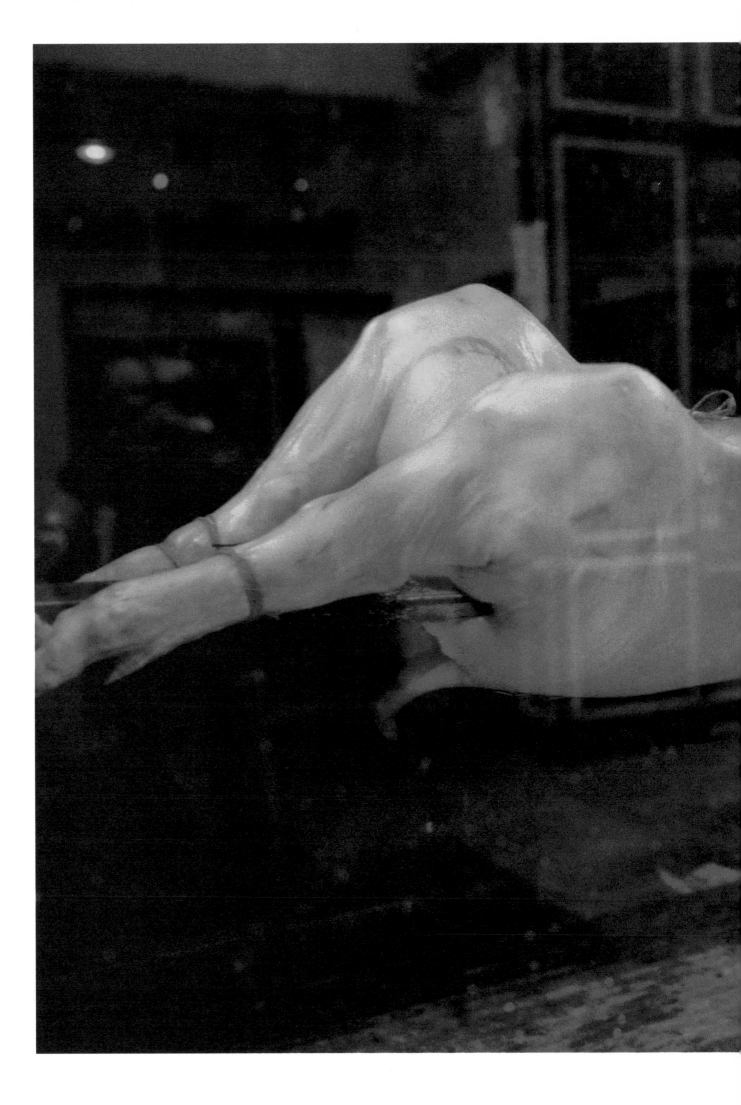

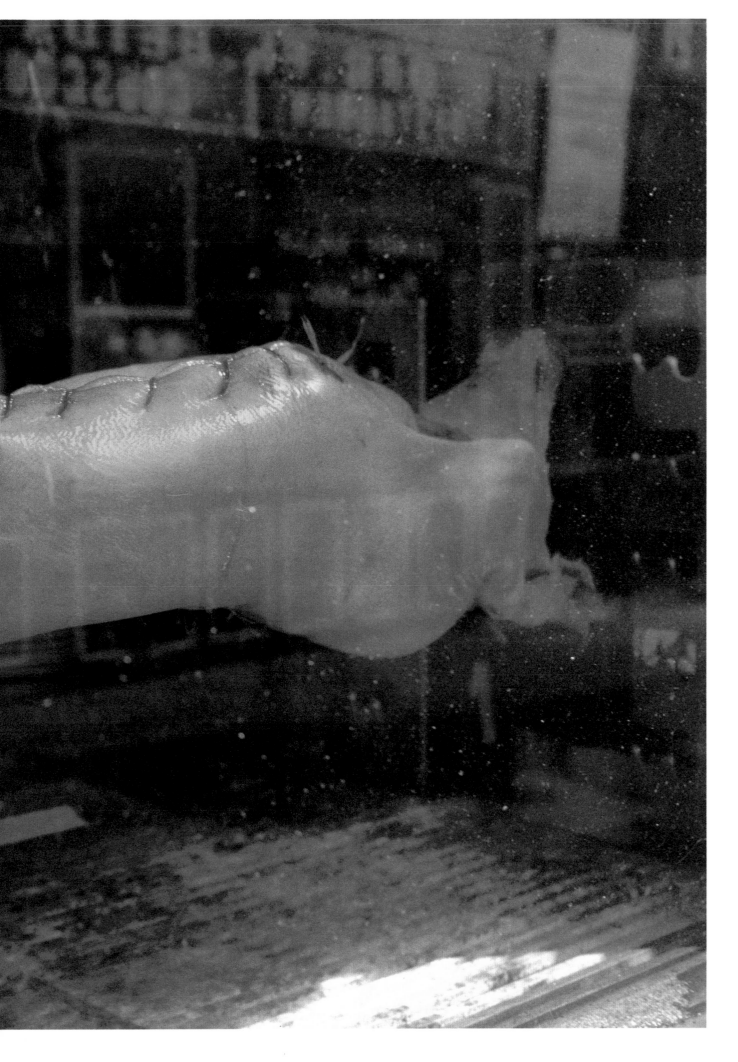

Le cochon dans
la vitrine, 1989

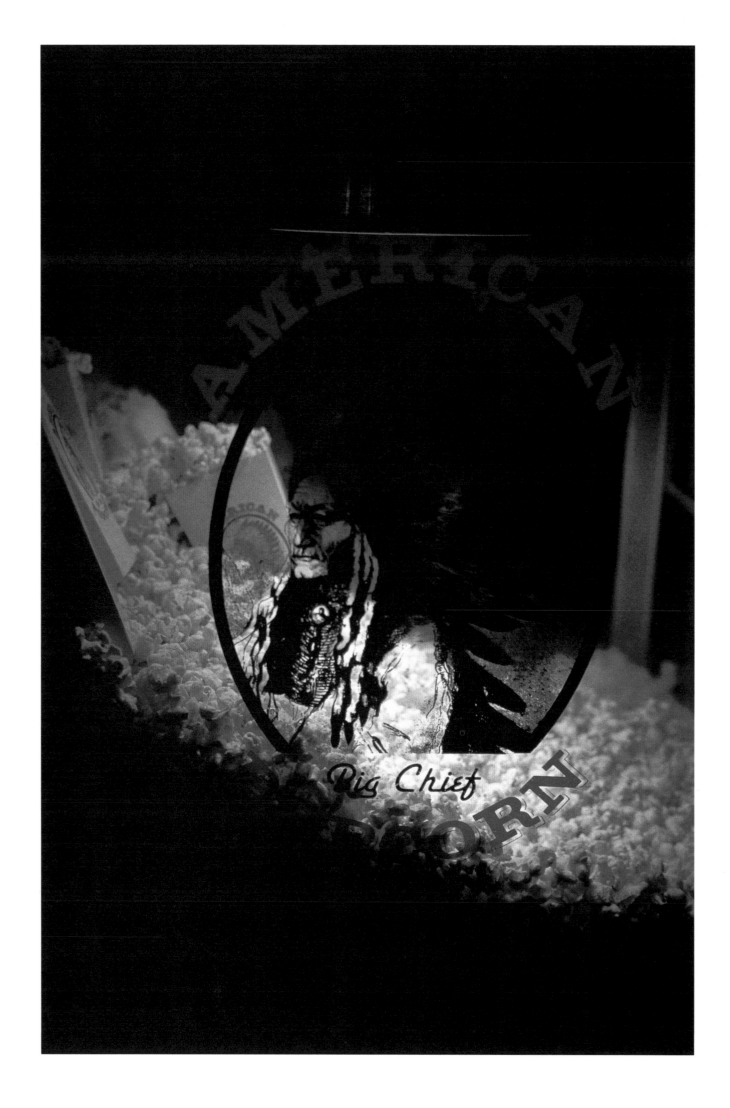

Les maïs
grillés
du cinéma,
1992

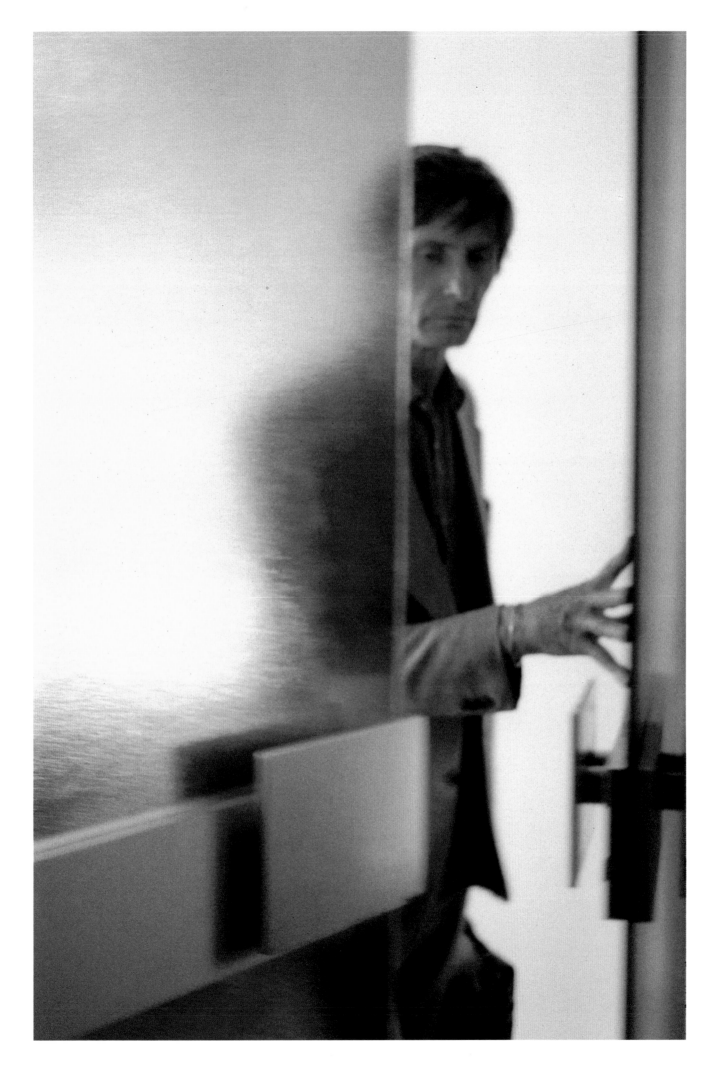

L'homme
qui pousse la
porte, 1986

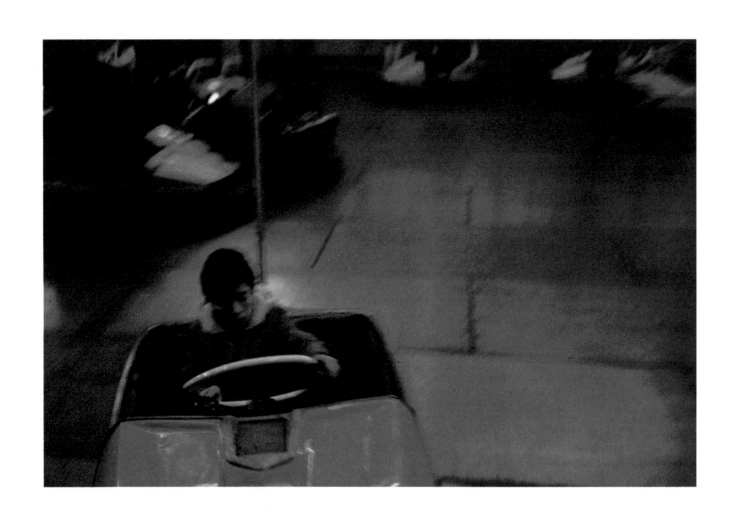

L'enfant
dans l'auto
tamponneuse,
1984

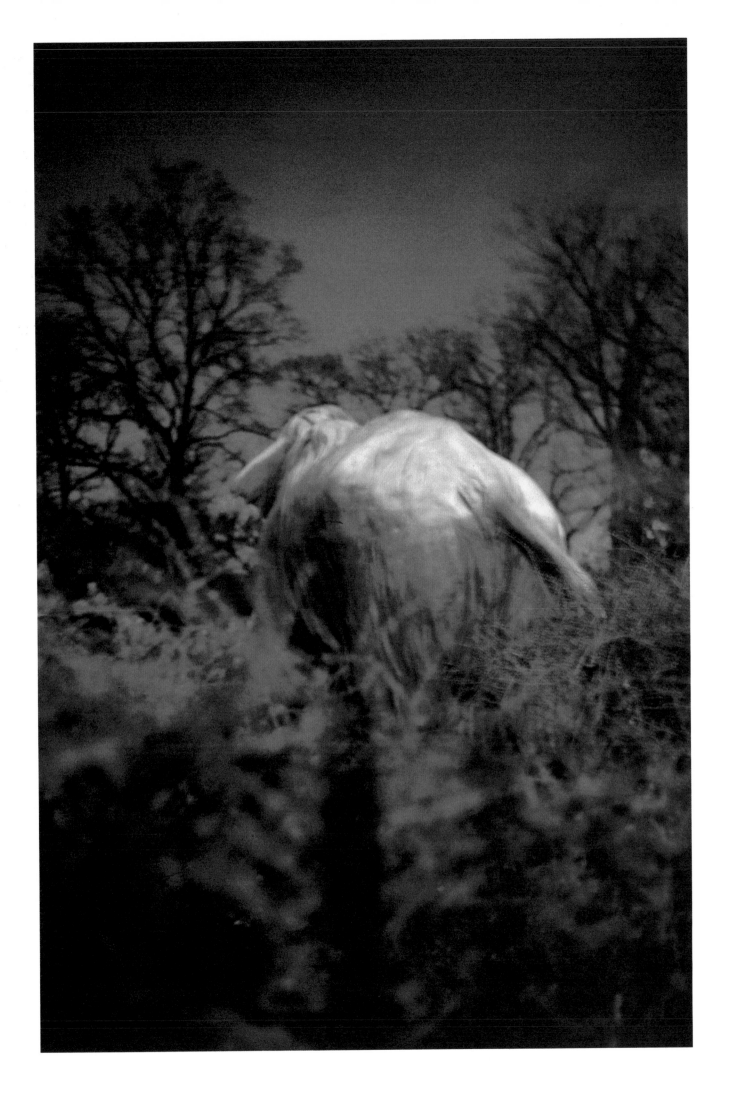

L'éléphant
dans
Paris, 1992

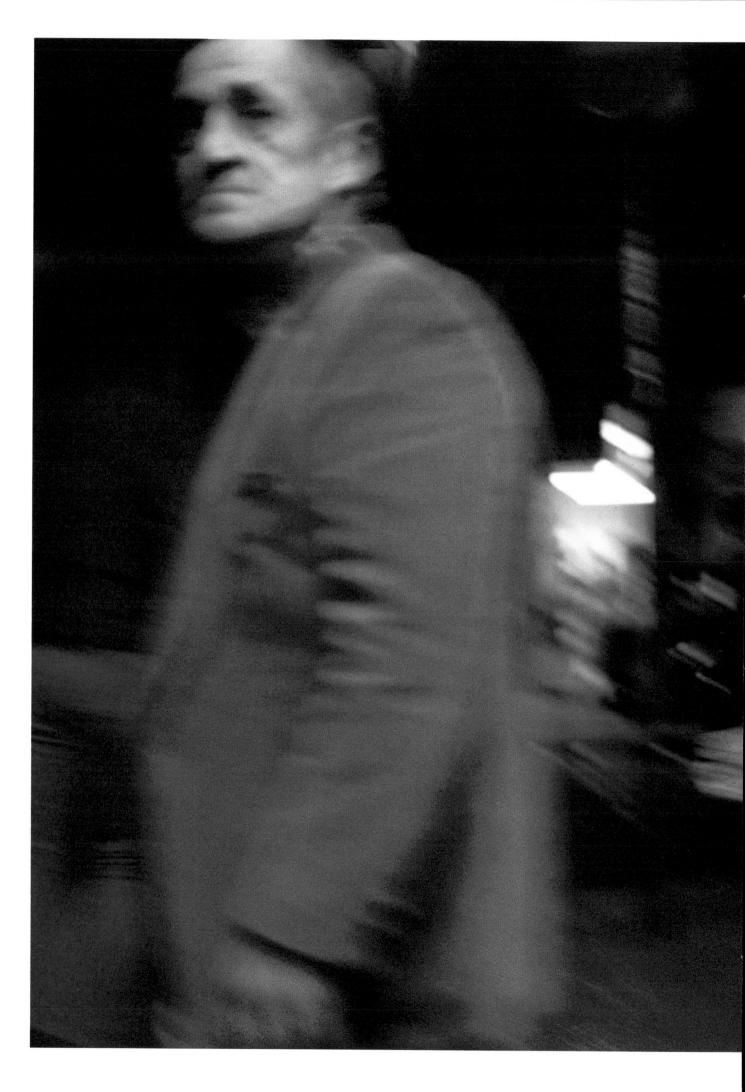

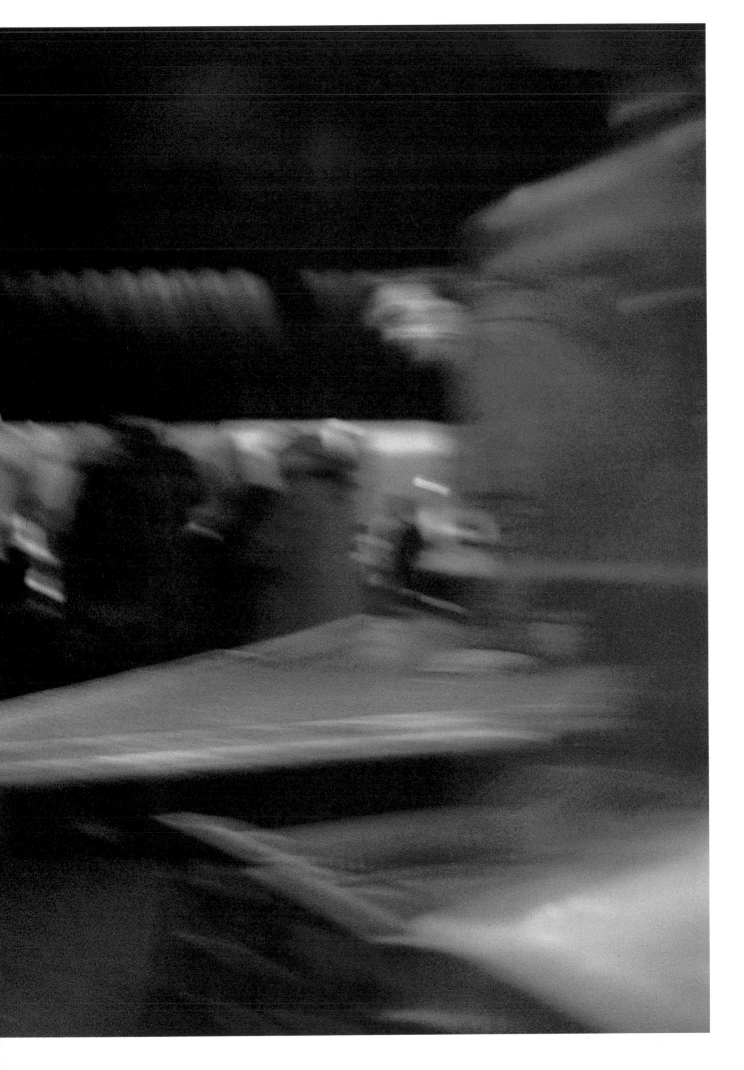

La fête foraine
à Pigalle, 1984

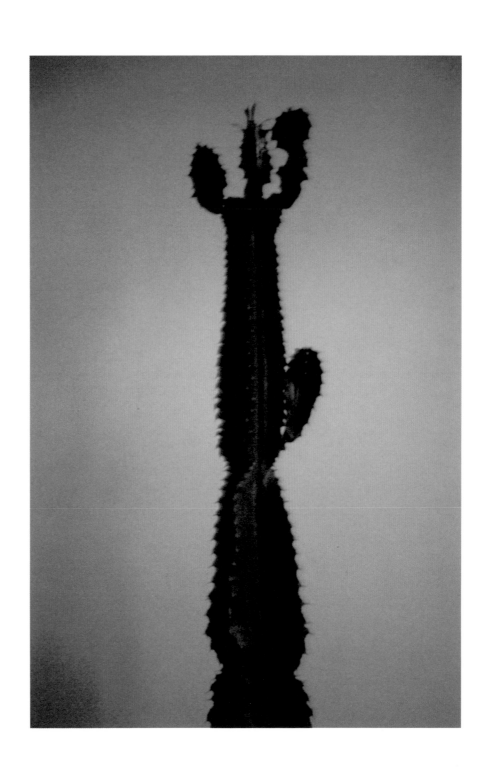

Le cactus rue
Véronèse, 1992

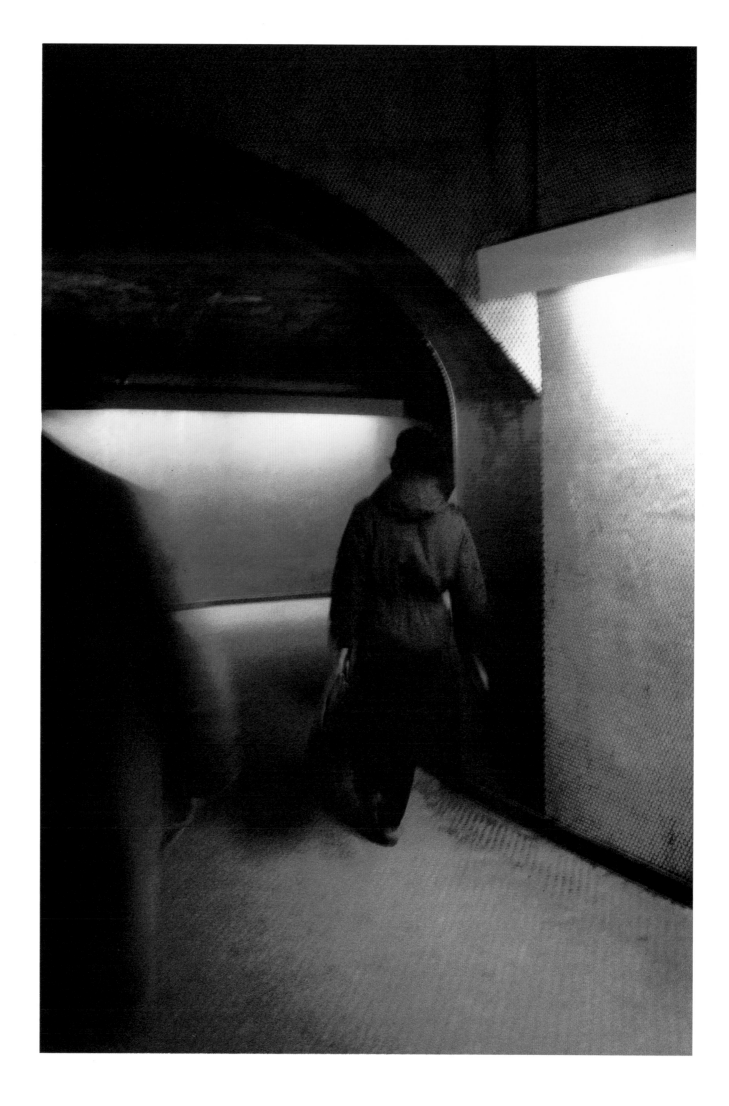

Le métro à
Auber, 1988

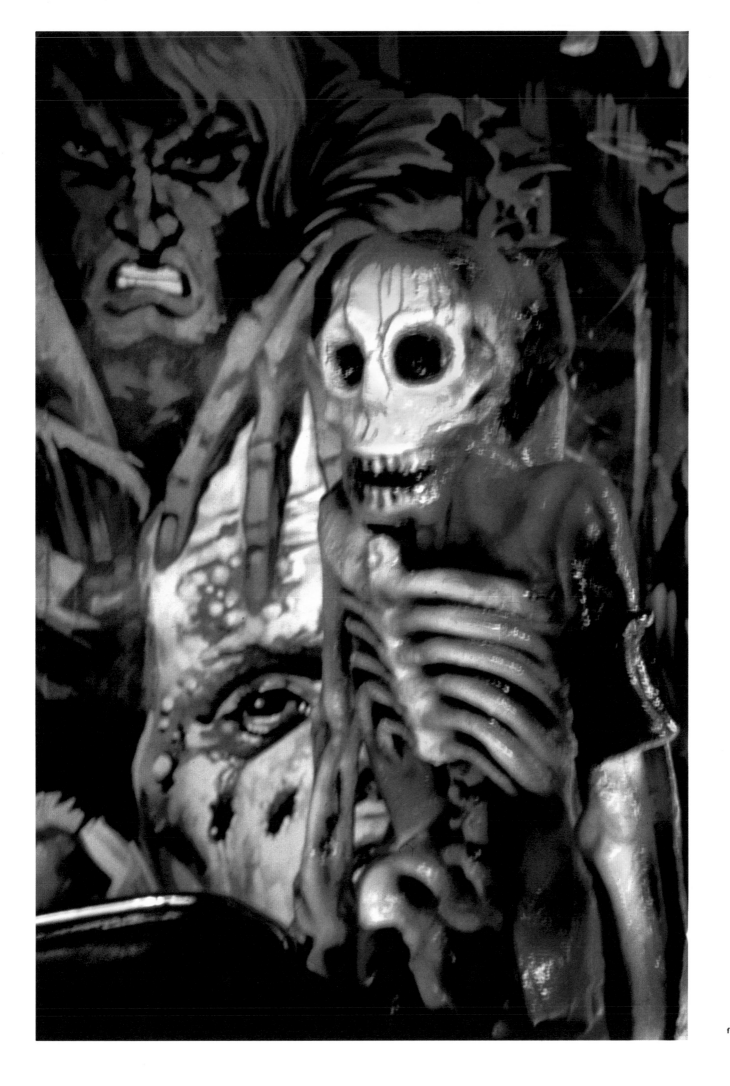

Le train
fantôme, 1993

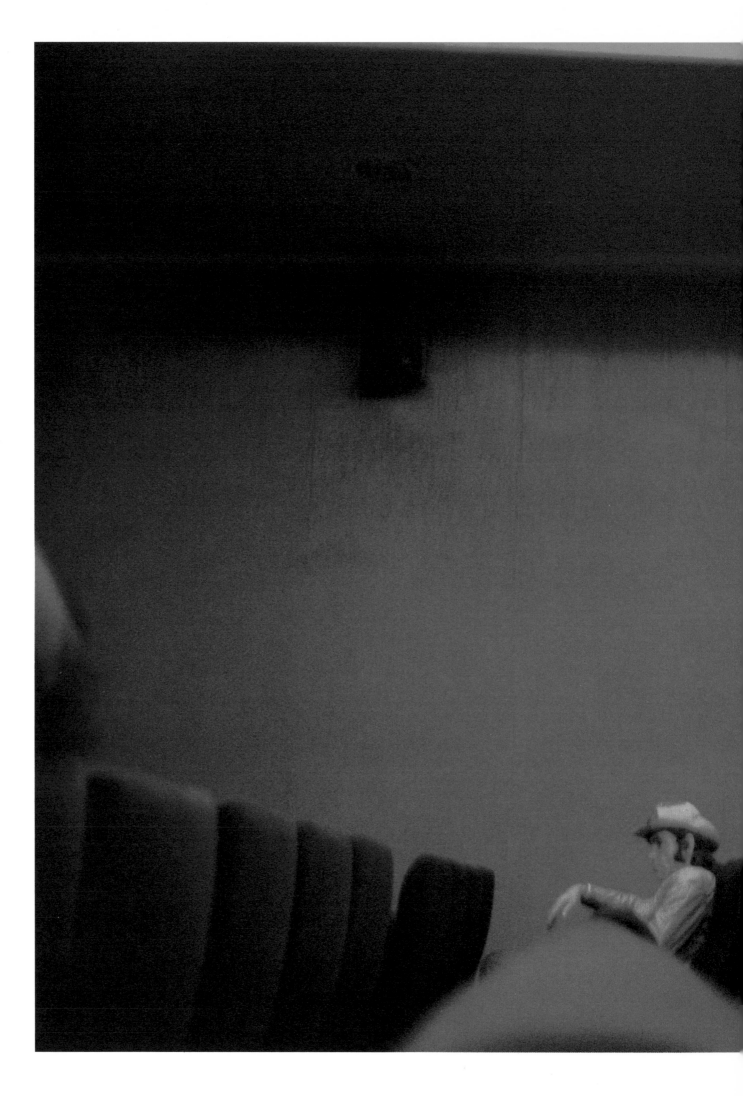

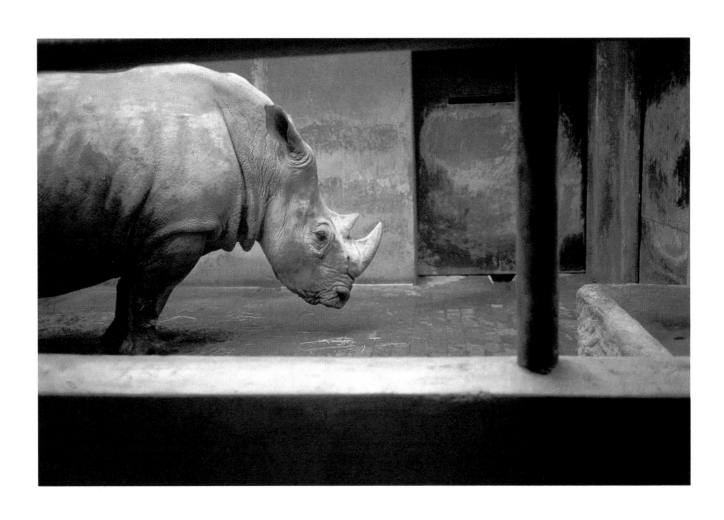

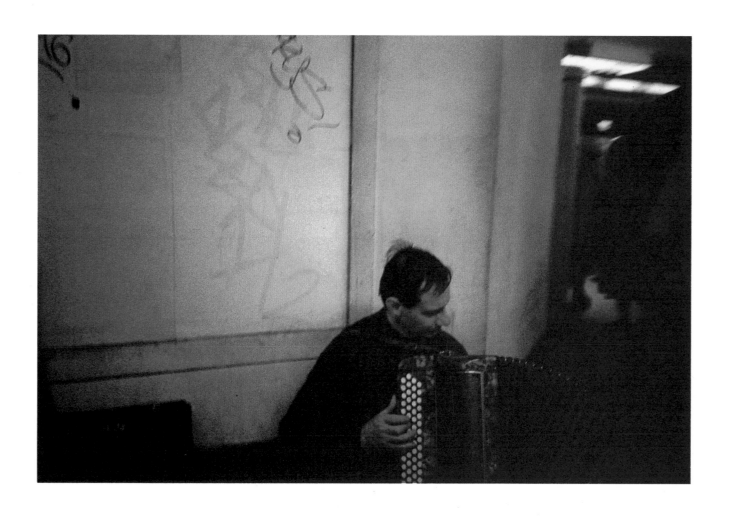

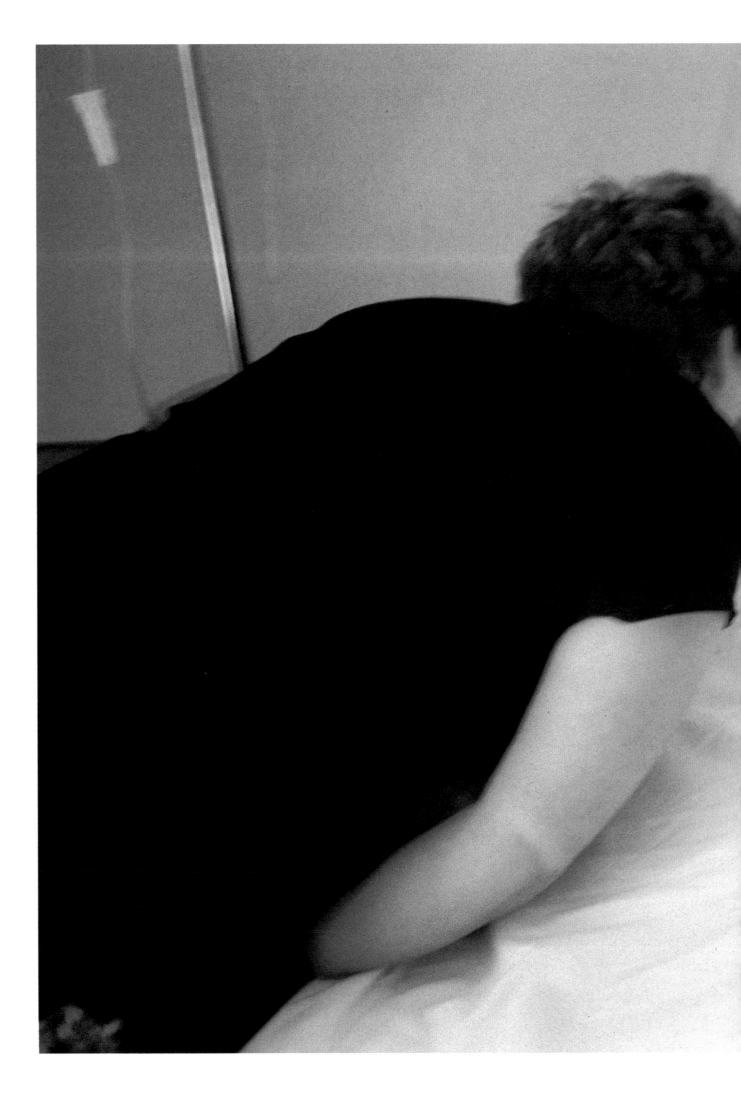

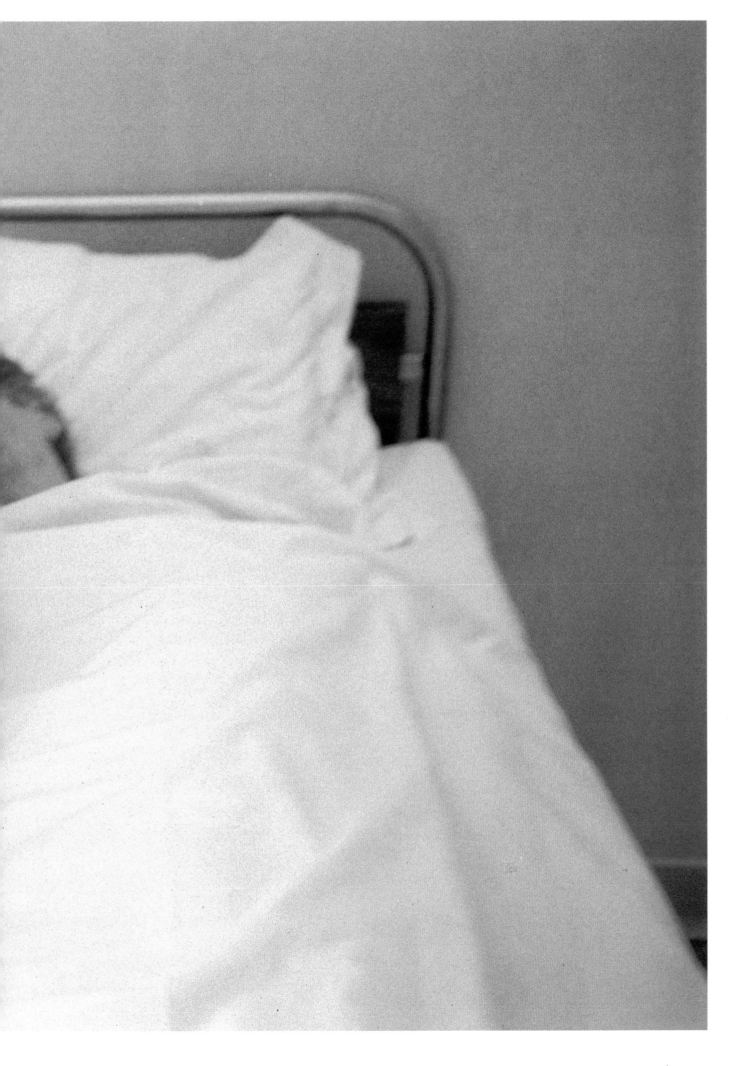

La chambre
d'hôpital, 1991

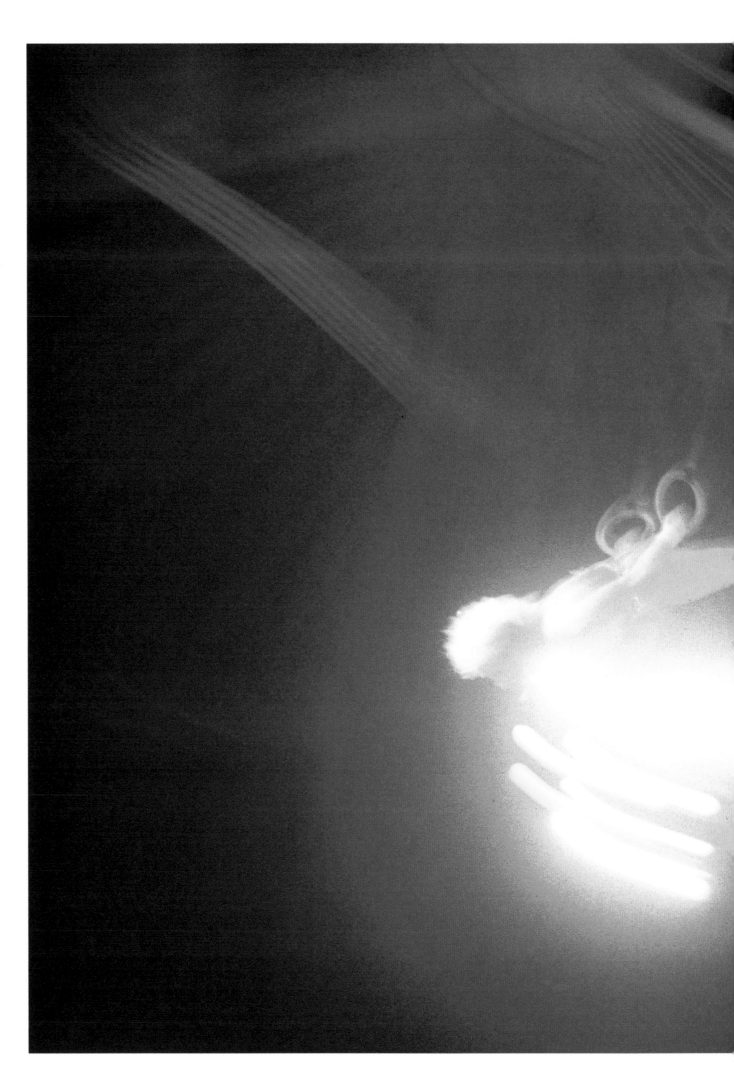

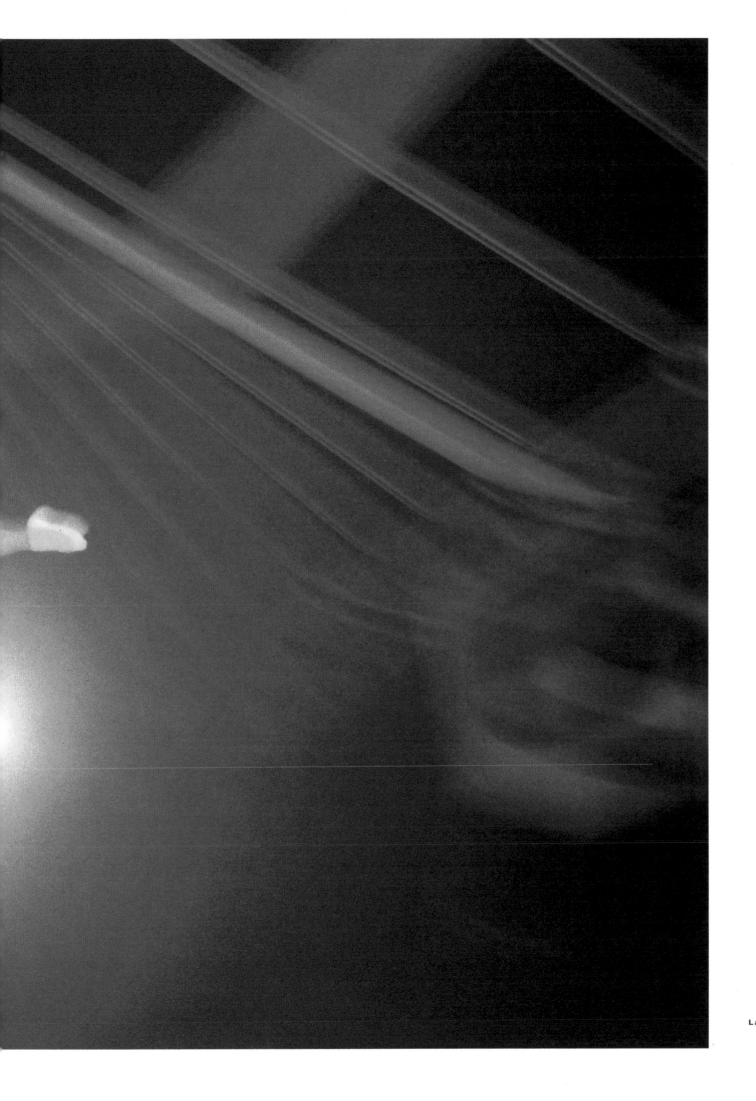

La trapéziste,
1991

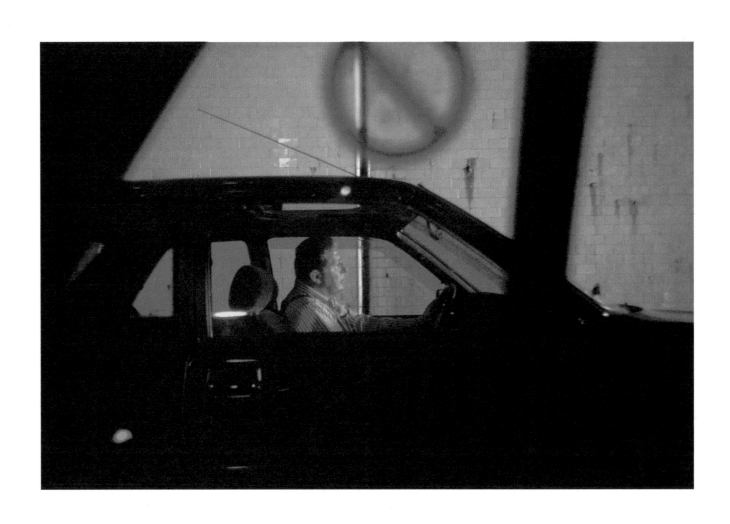

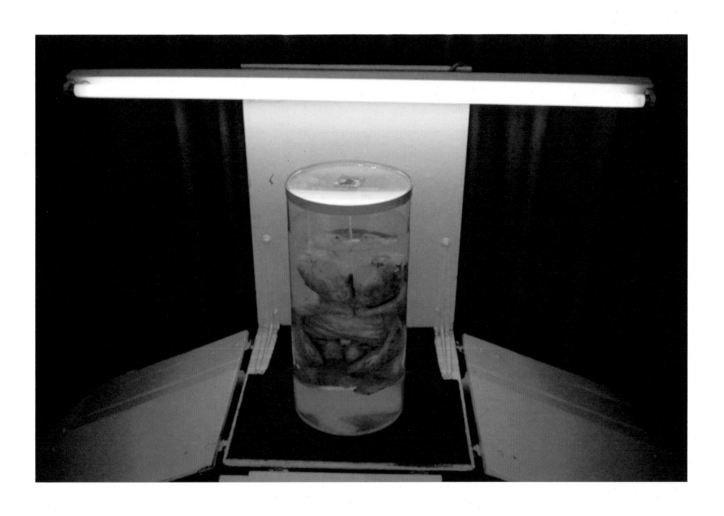

La foire
du Trône, 1993

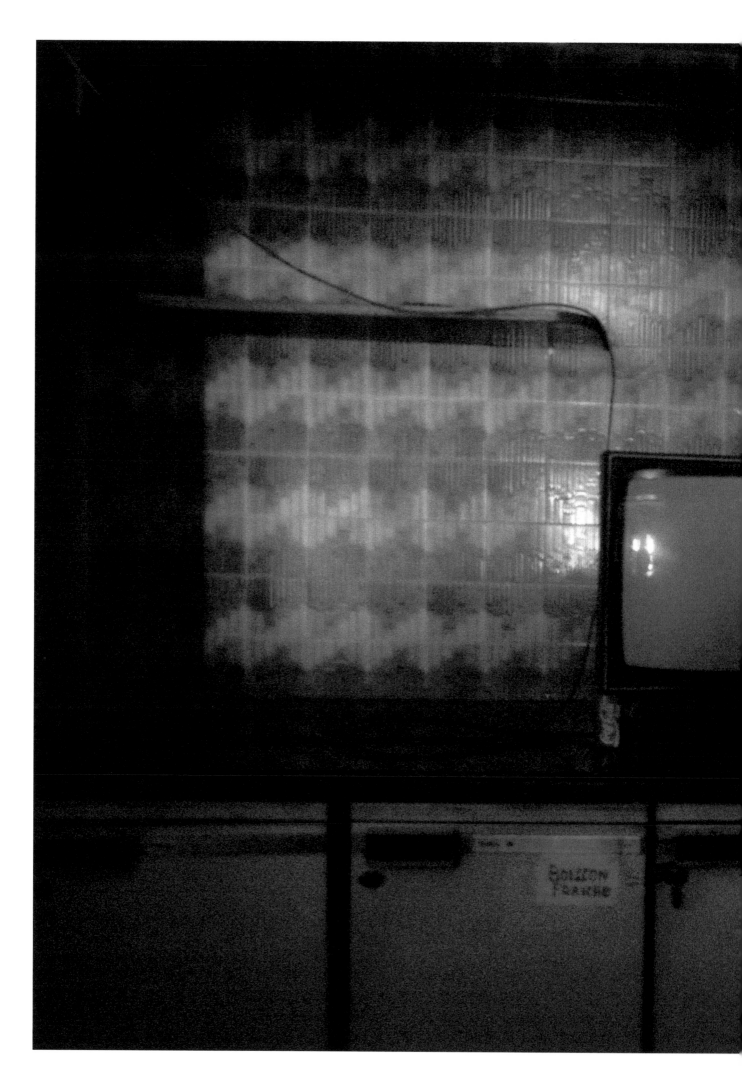

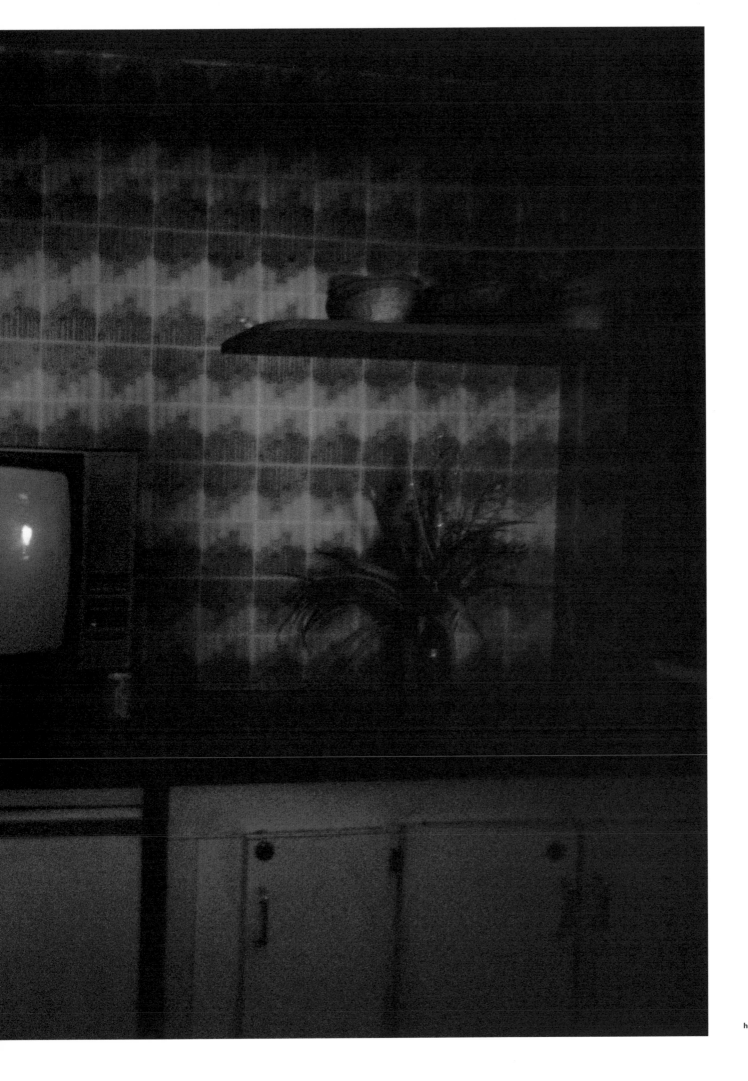

La télé au
hammam, 1992

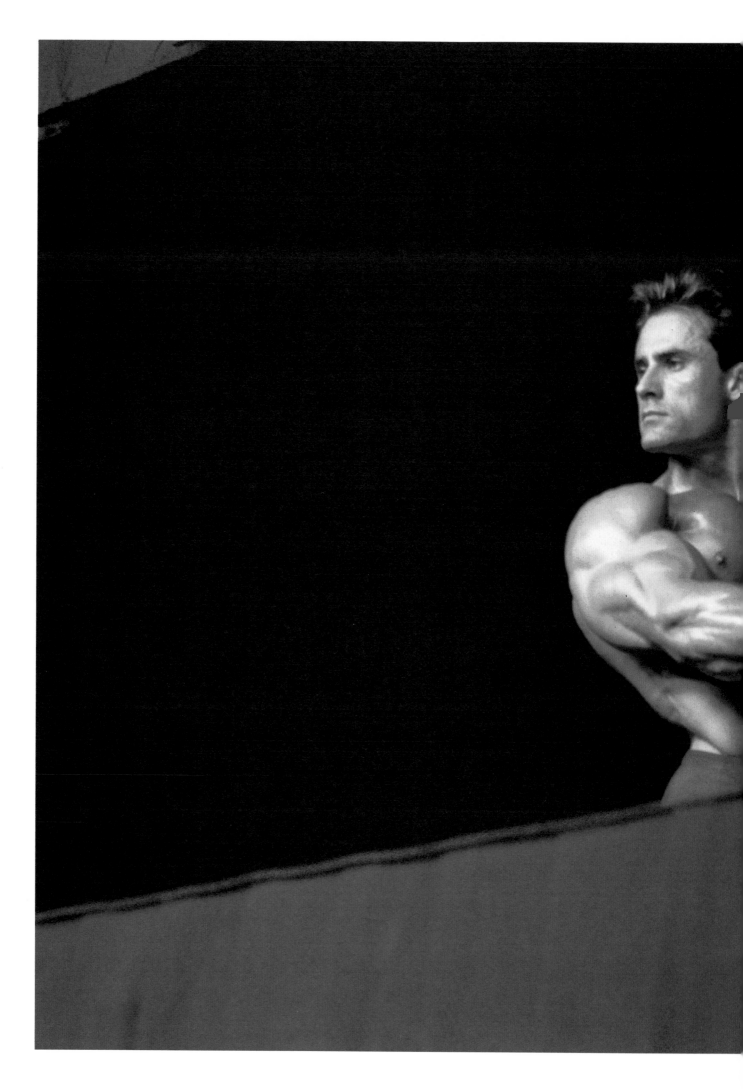

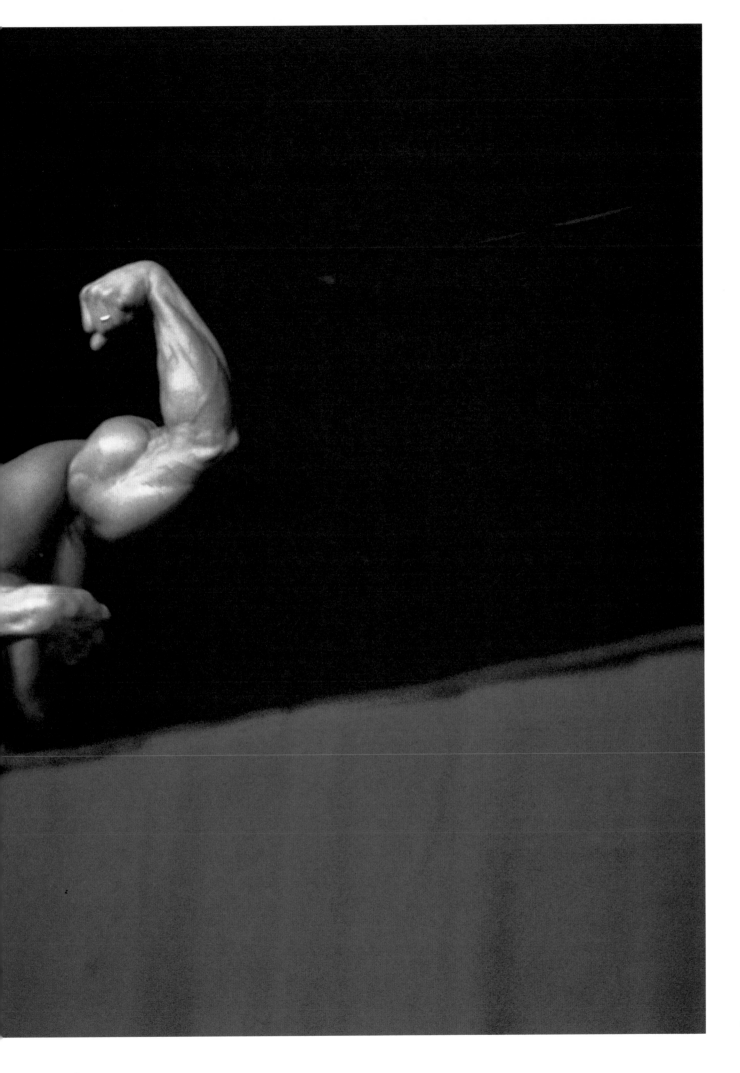

Le graffiti
dans la nuit,
1992

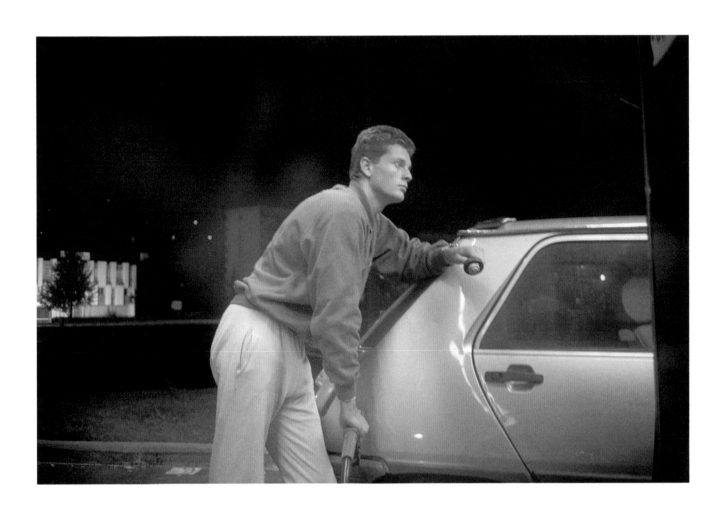

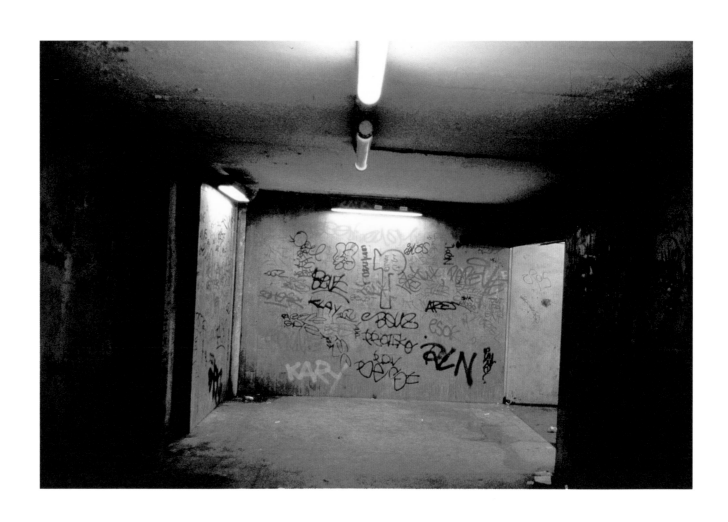

L'entrée du
métro, 1993

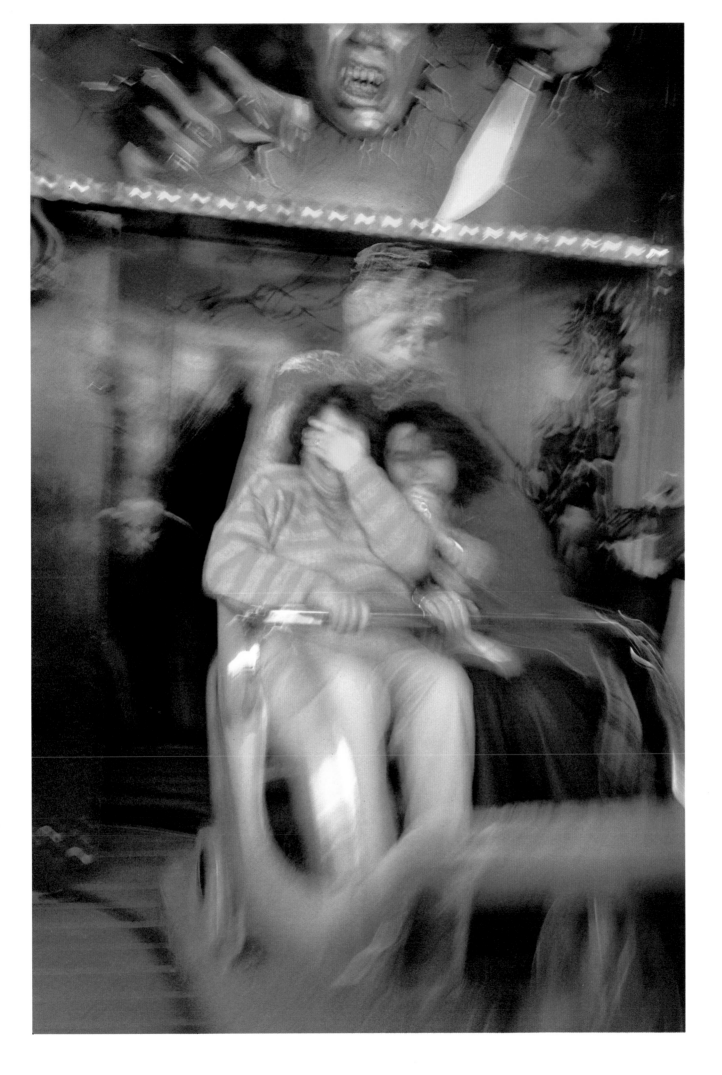

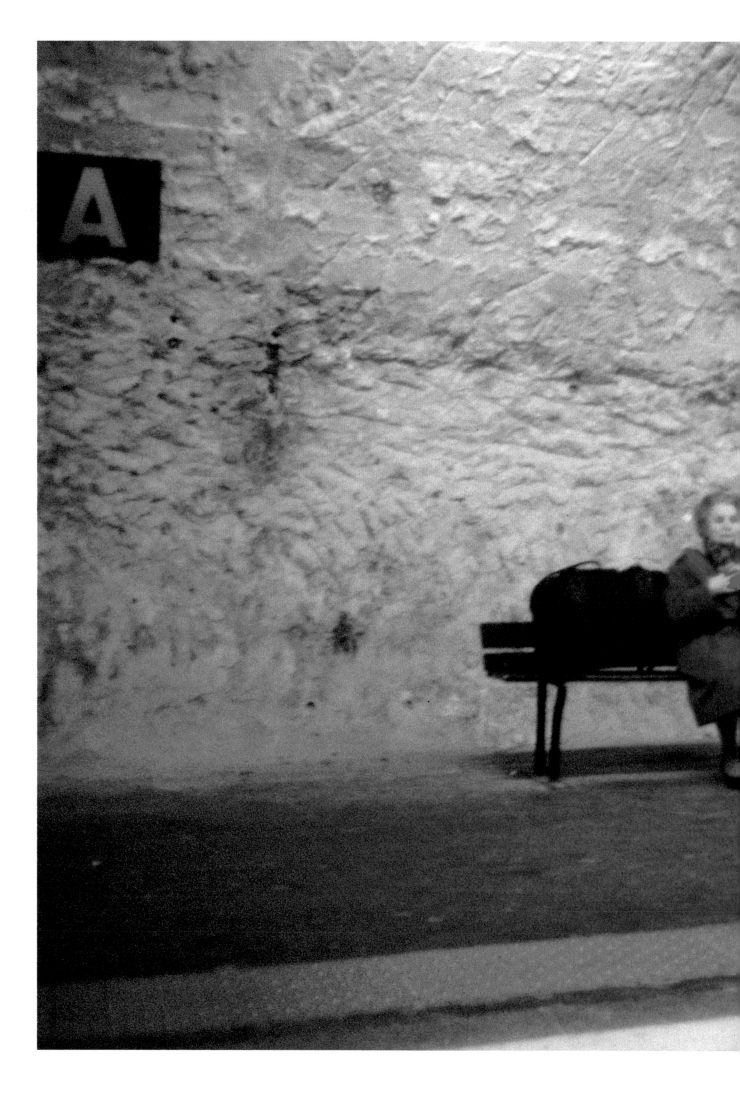

La femme sur
un banc à
Alésia, 1993

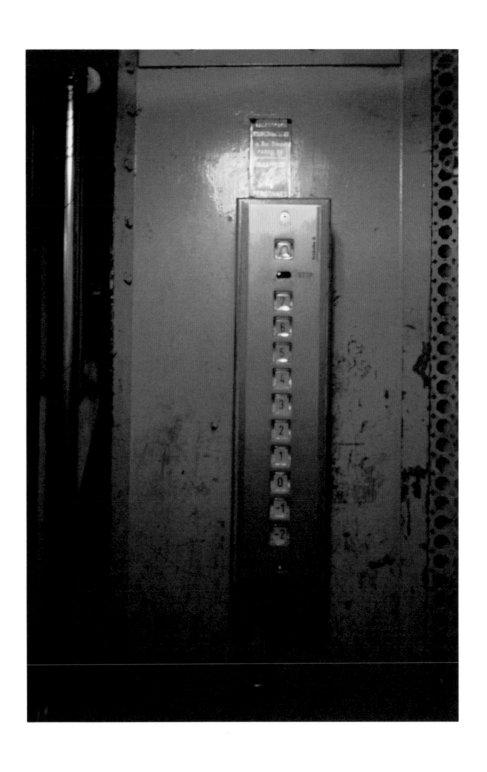

Le nageur nu,
1990

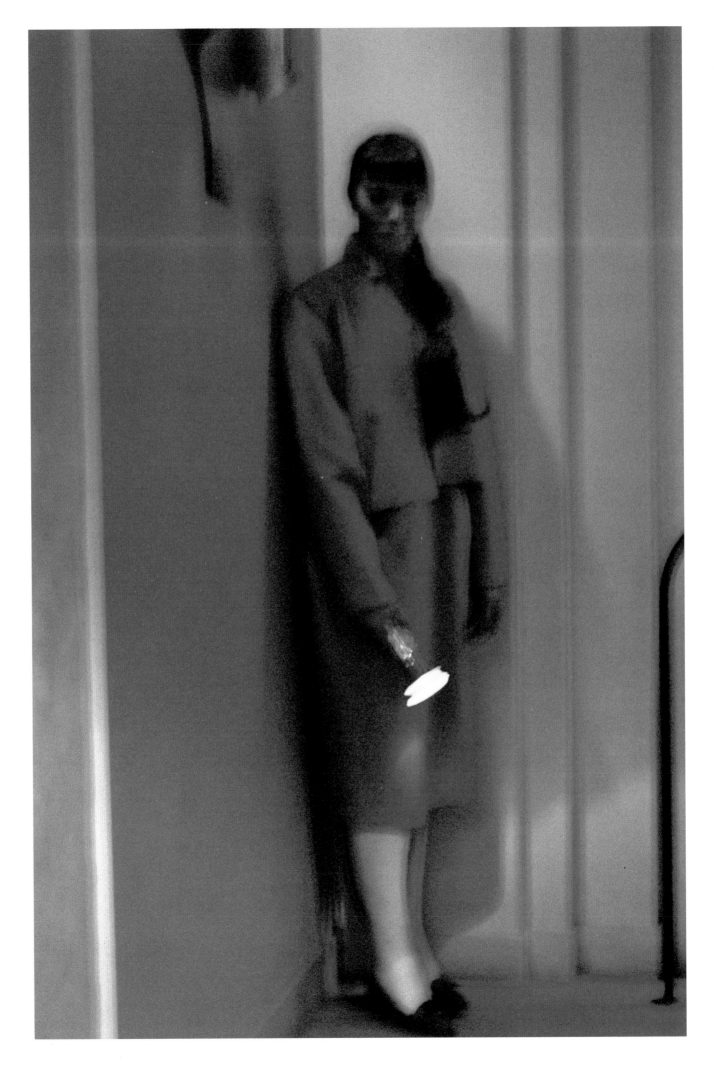

La femme du
musée Grévin,
1988

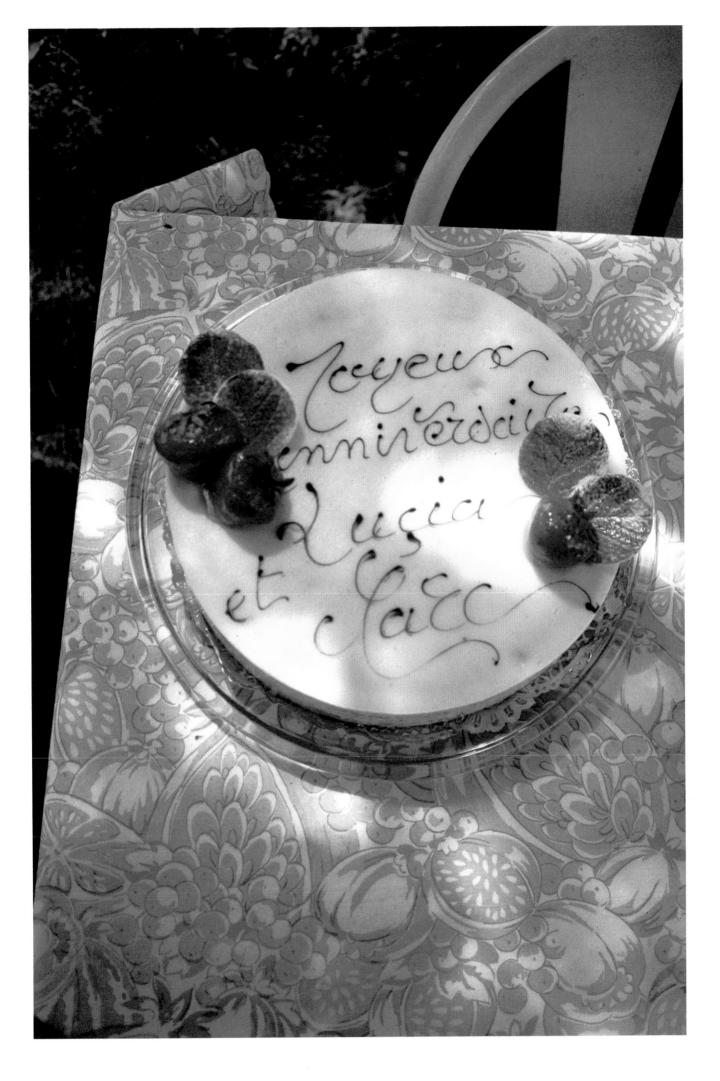

Le gâteau
d'anniversaire,
1993

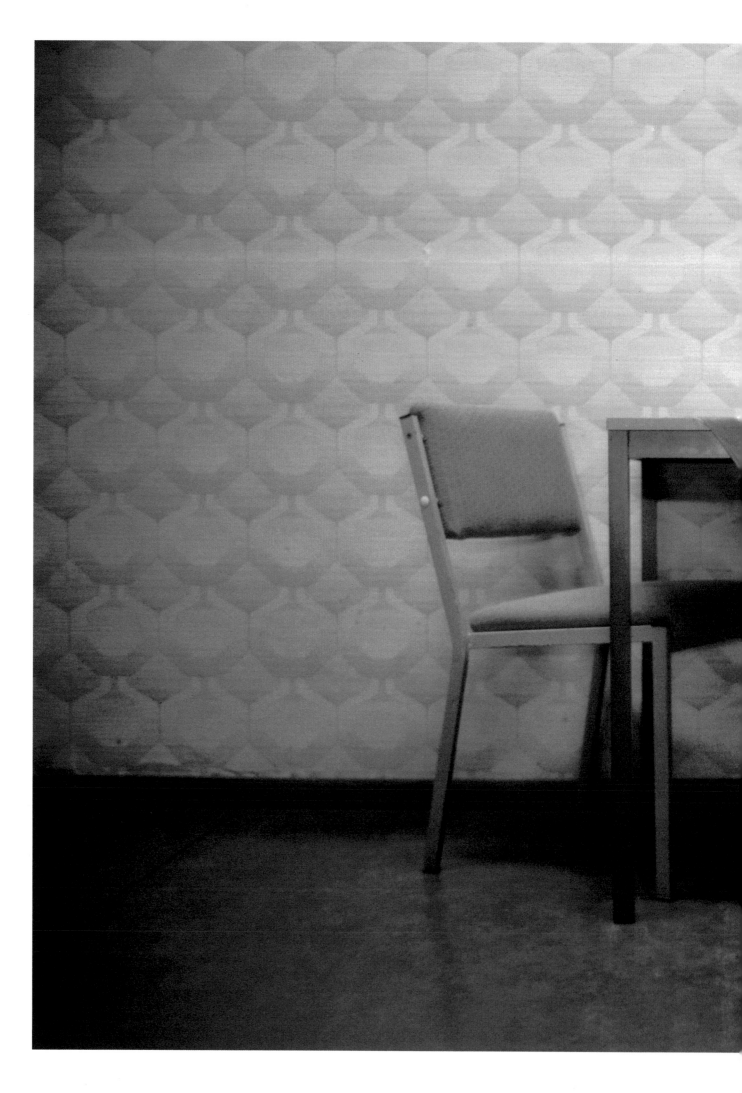

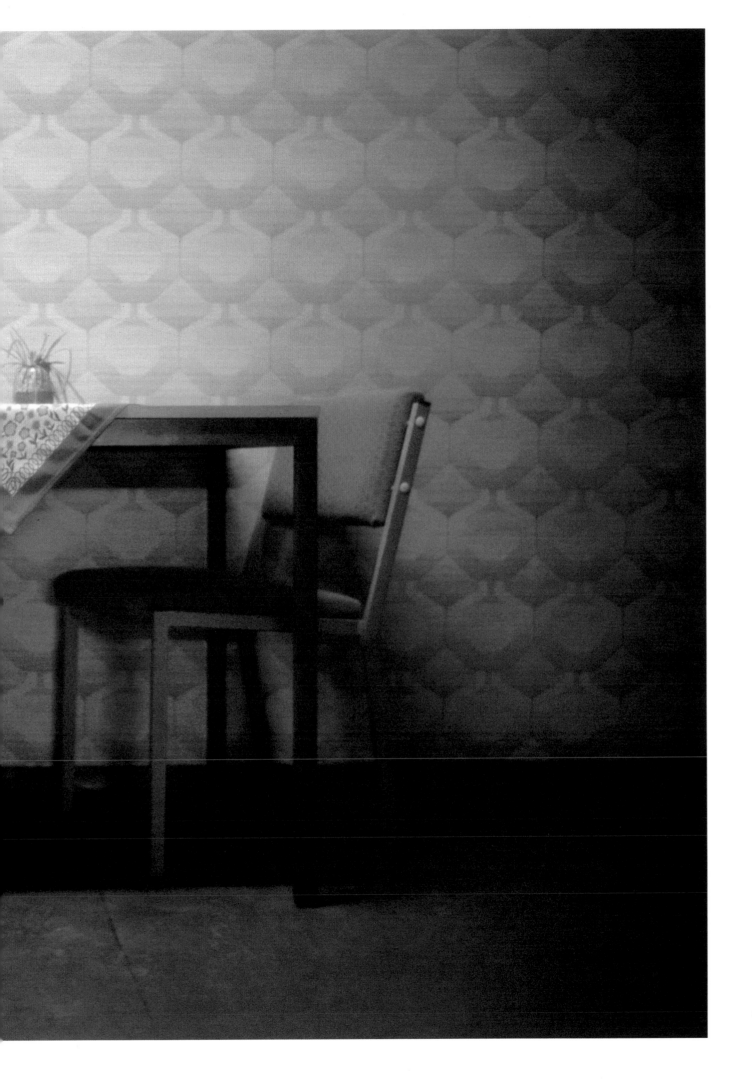

La petite
plante sur la
table, 1989

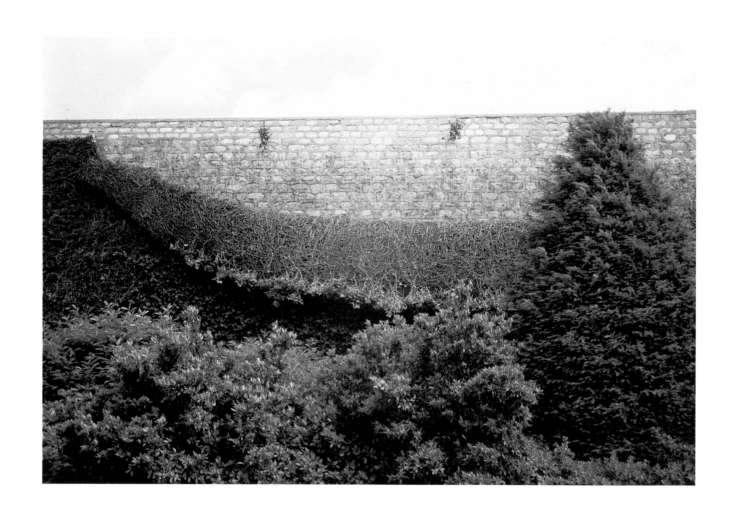

Le mur du musée Rodin, 1986

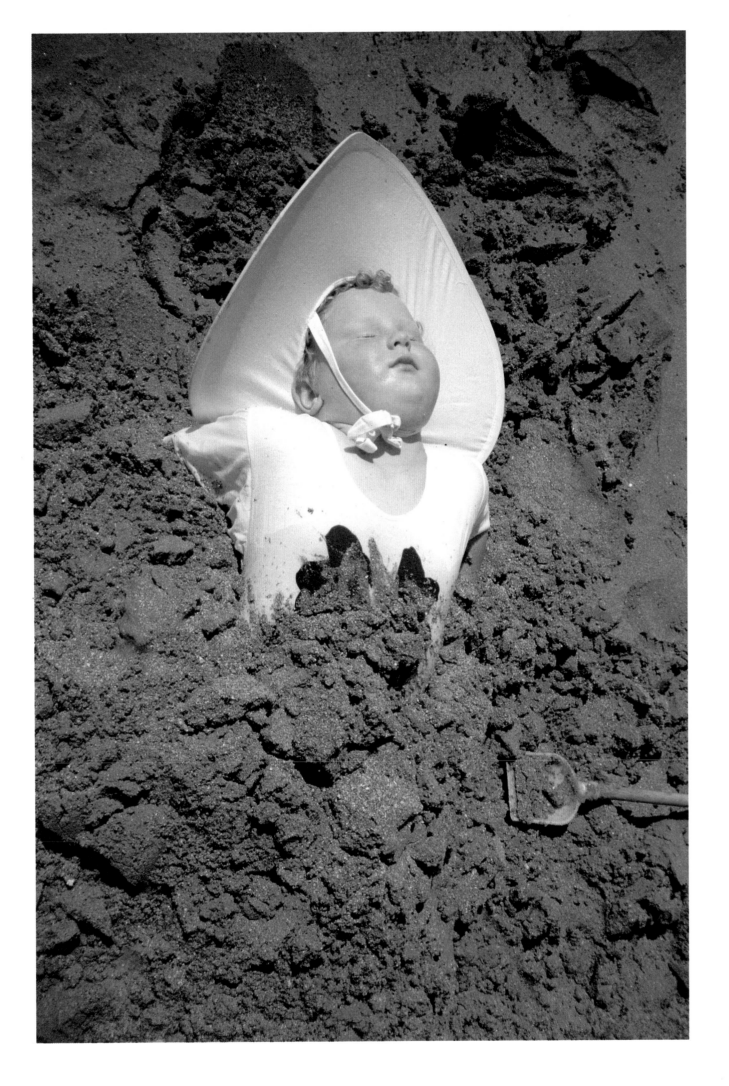

L'enfant dans
le sable, 1993

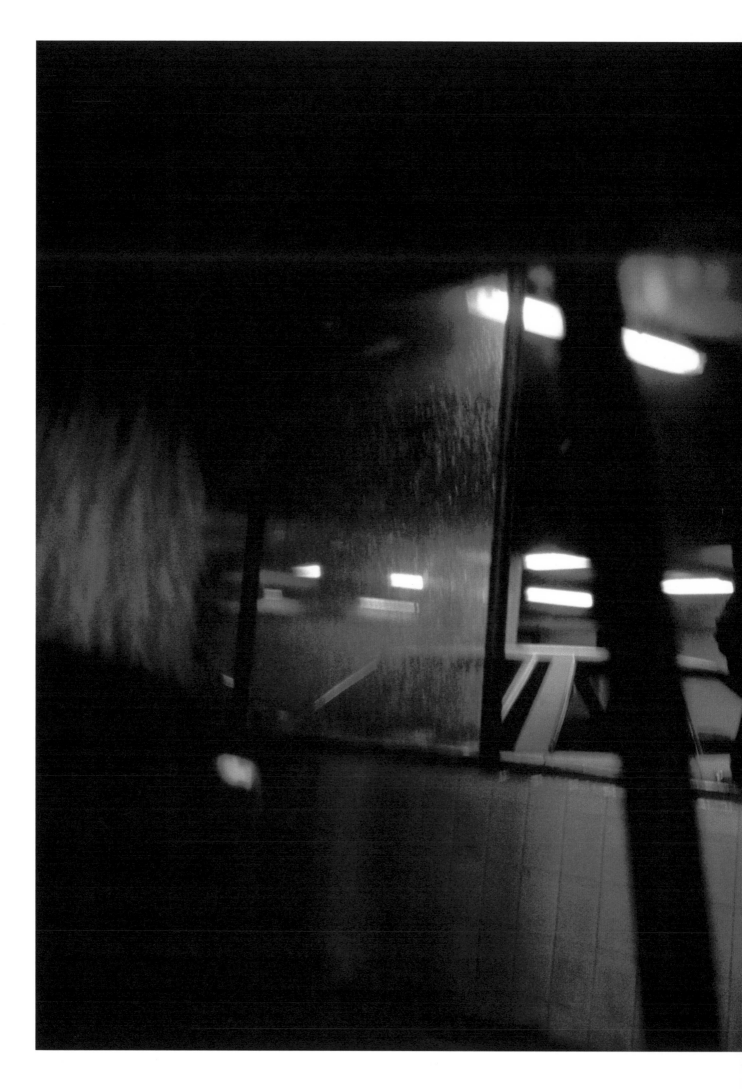

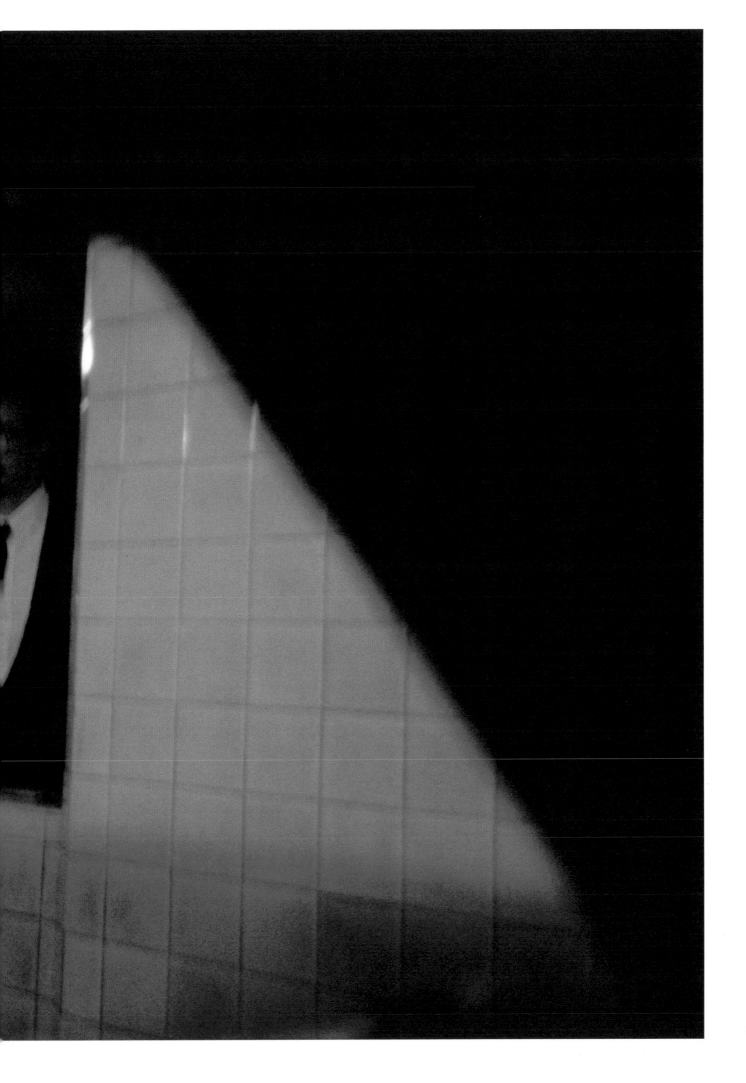

L'homme
dans un
parking, 1992

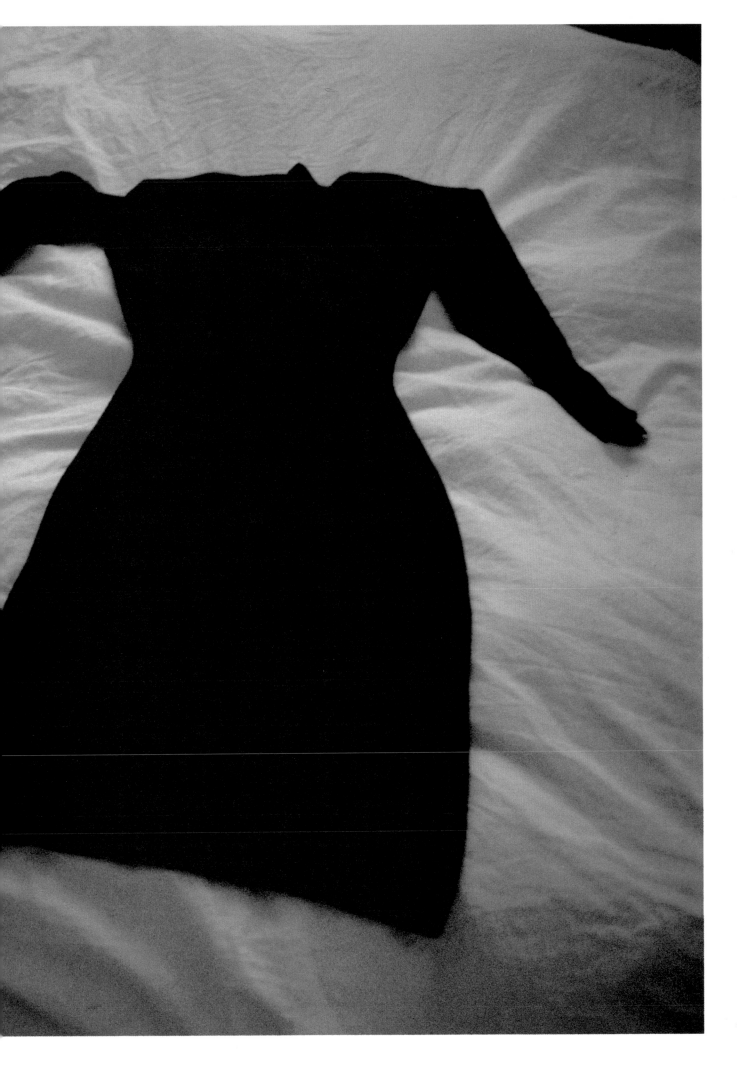

L'homme dans
la nuit, 1986

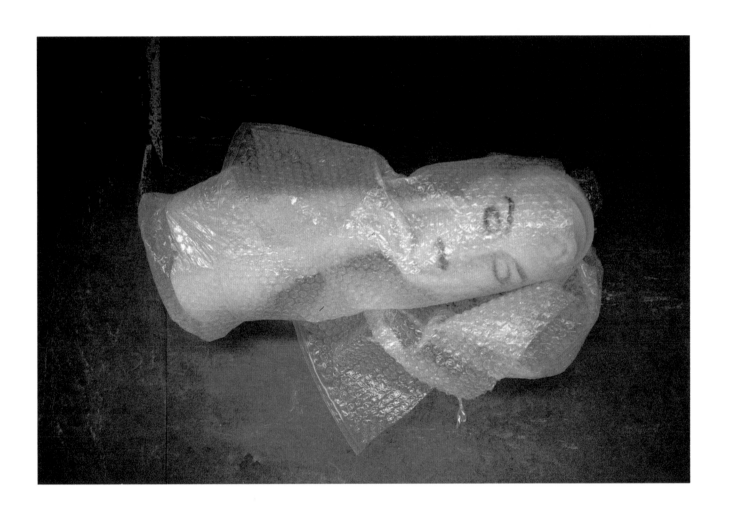

La tête
enveloppée,
1991

63

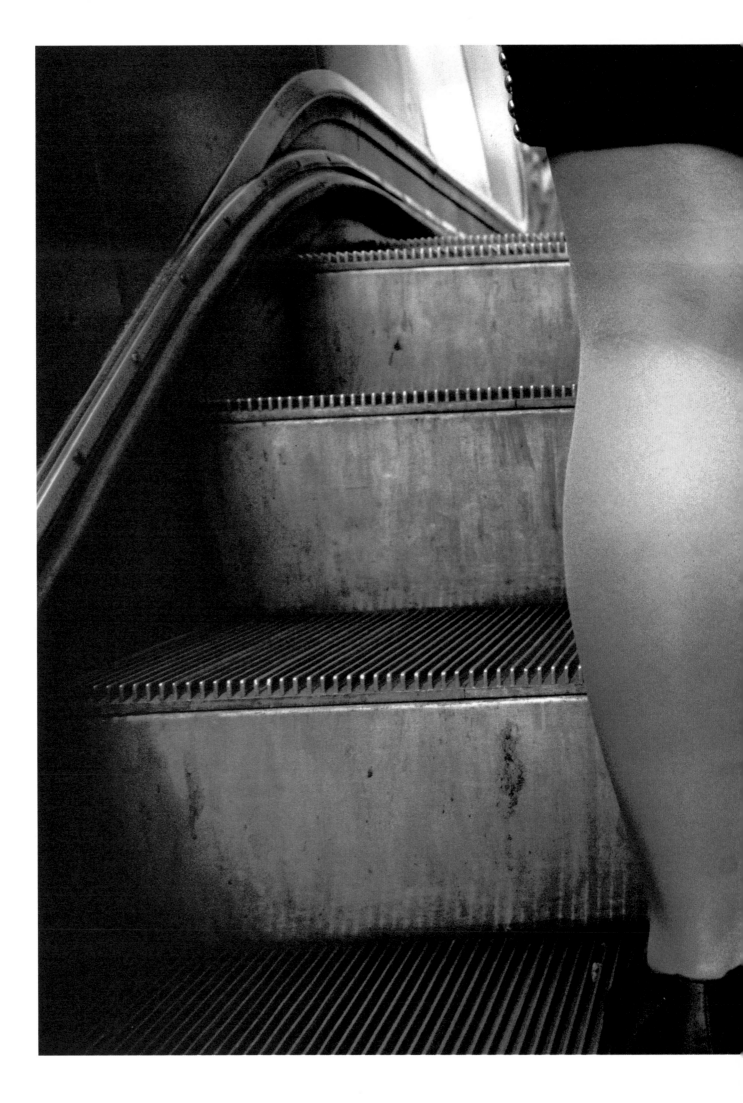

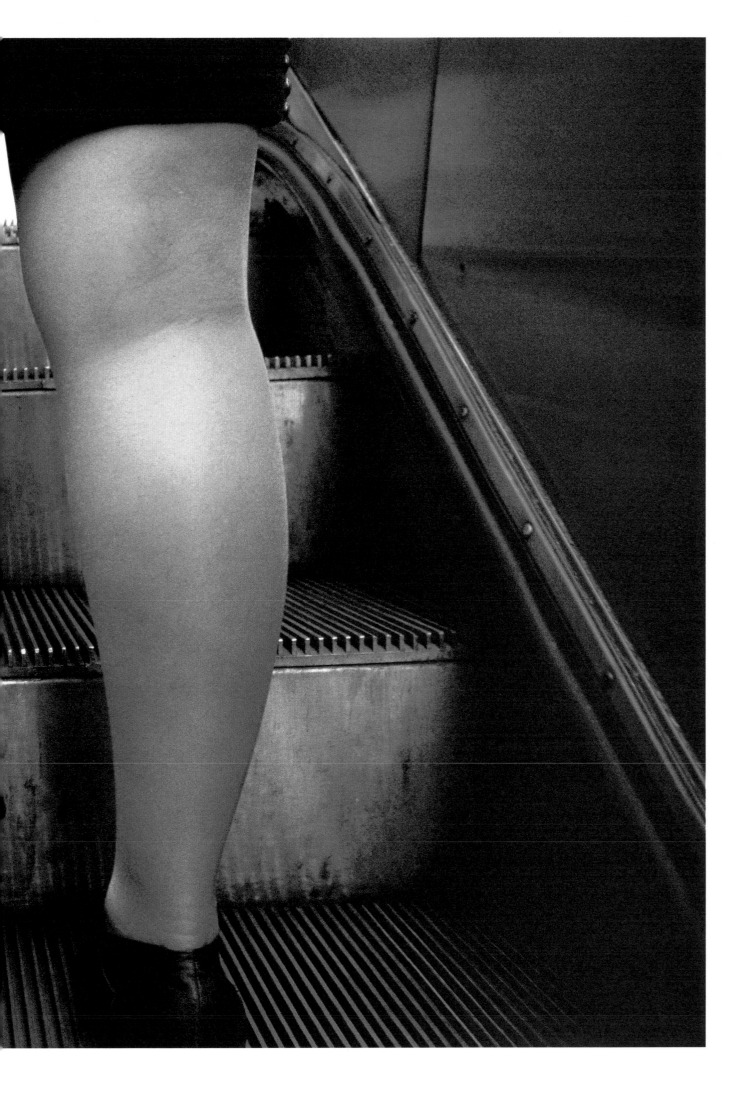

Les jambes
dans
l'escalator,
1993

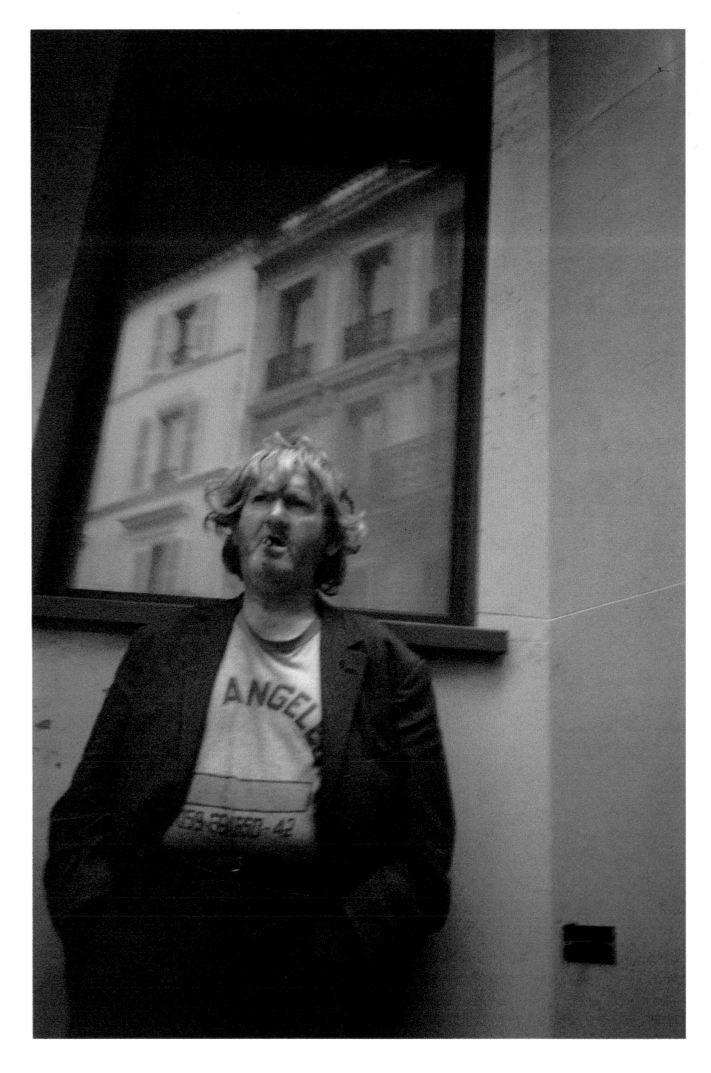

L'homme
rue du Colisée,
1984

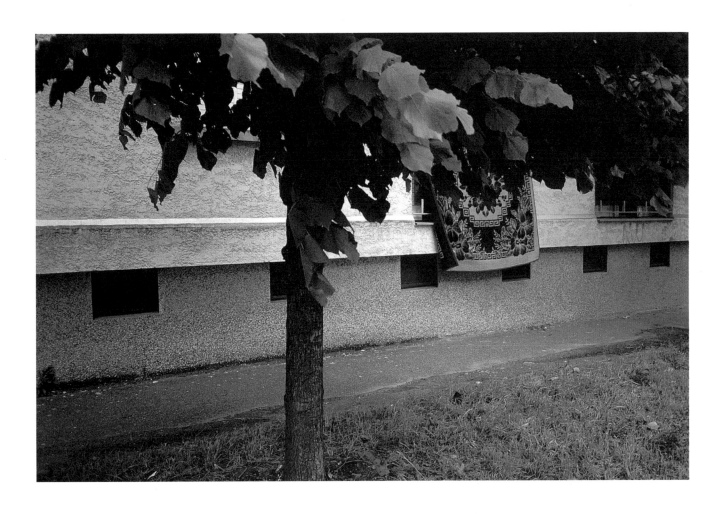

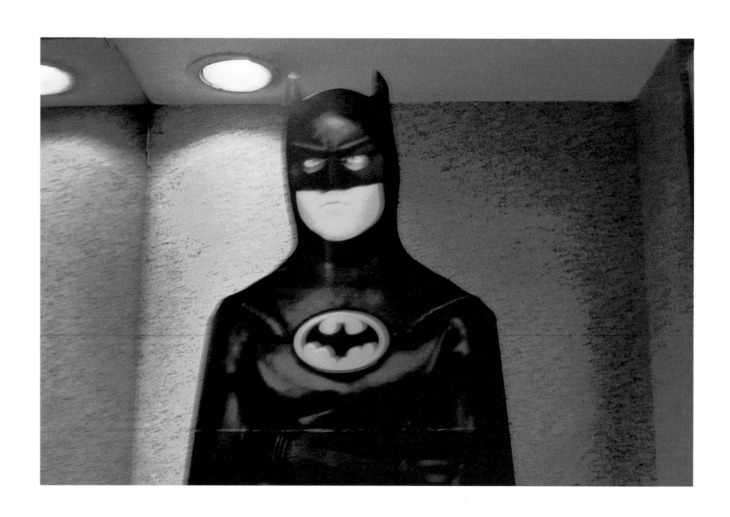

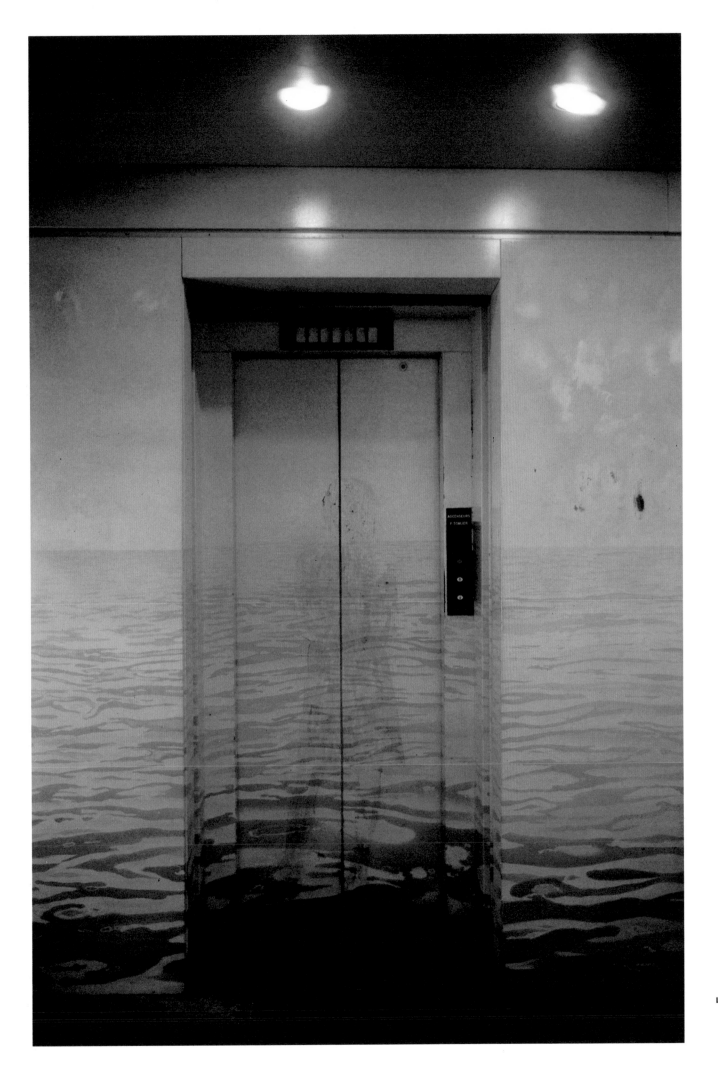

La porte peinte
de l'ascenseur,
1992

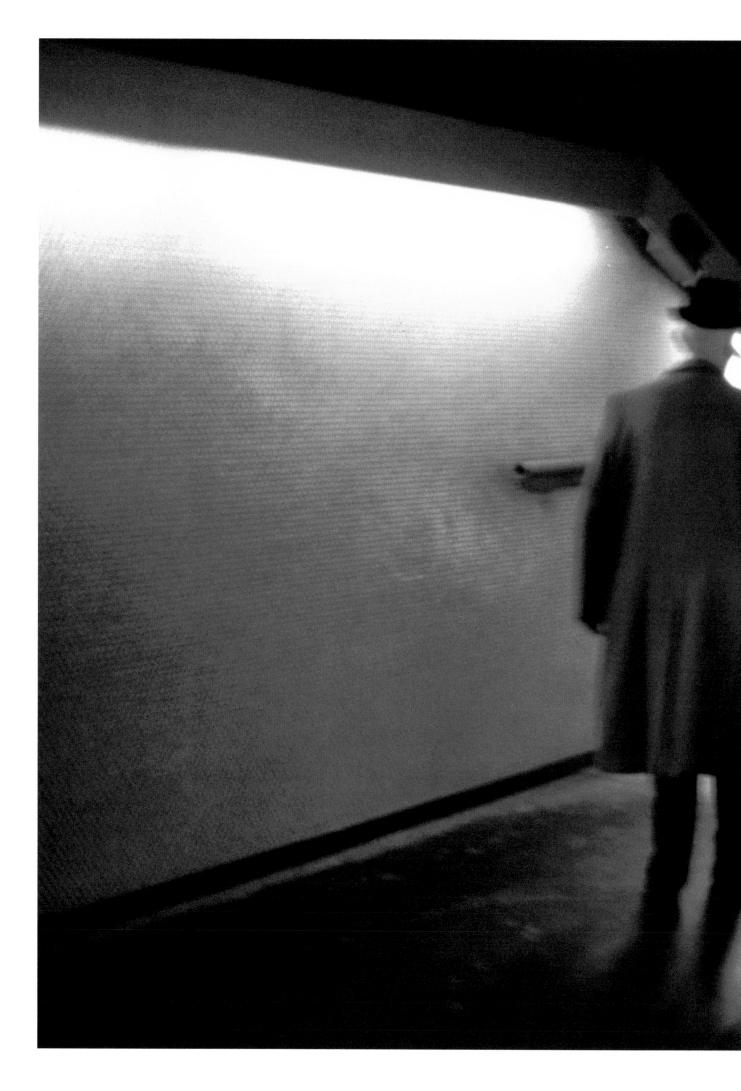

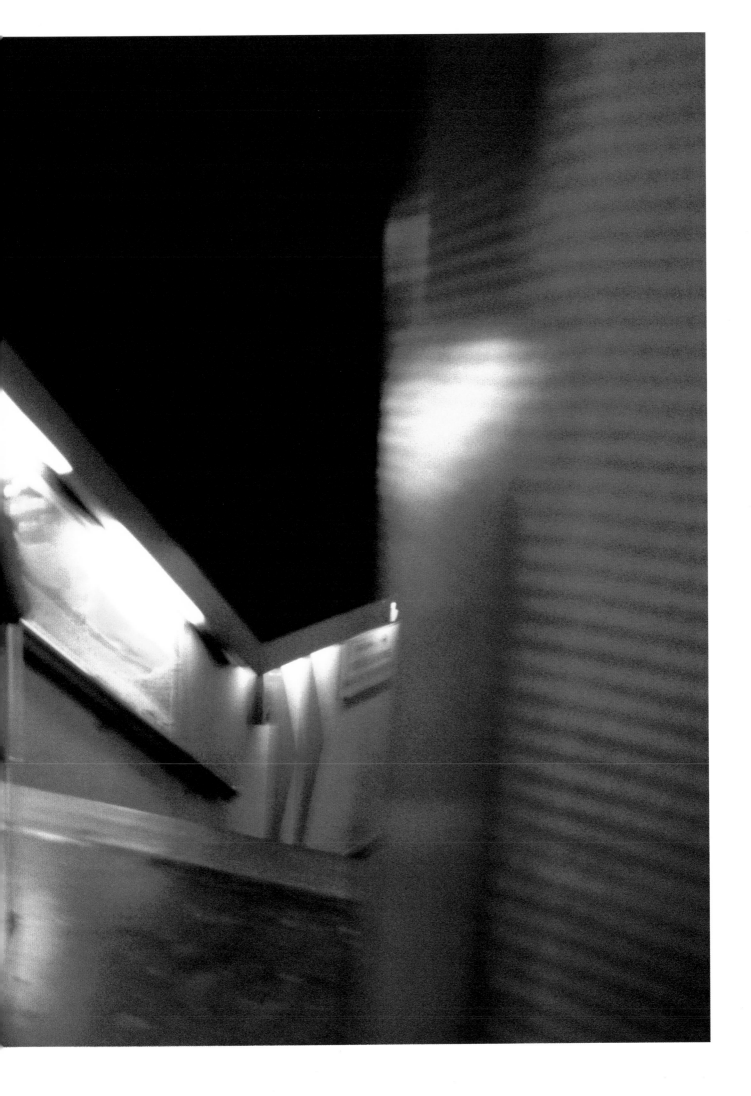

L'homme à la
canne, 1992

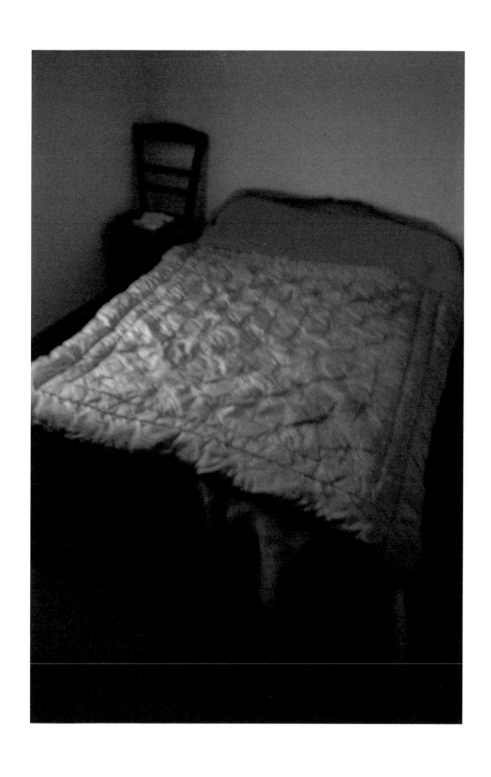

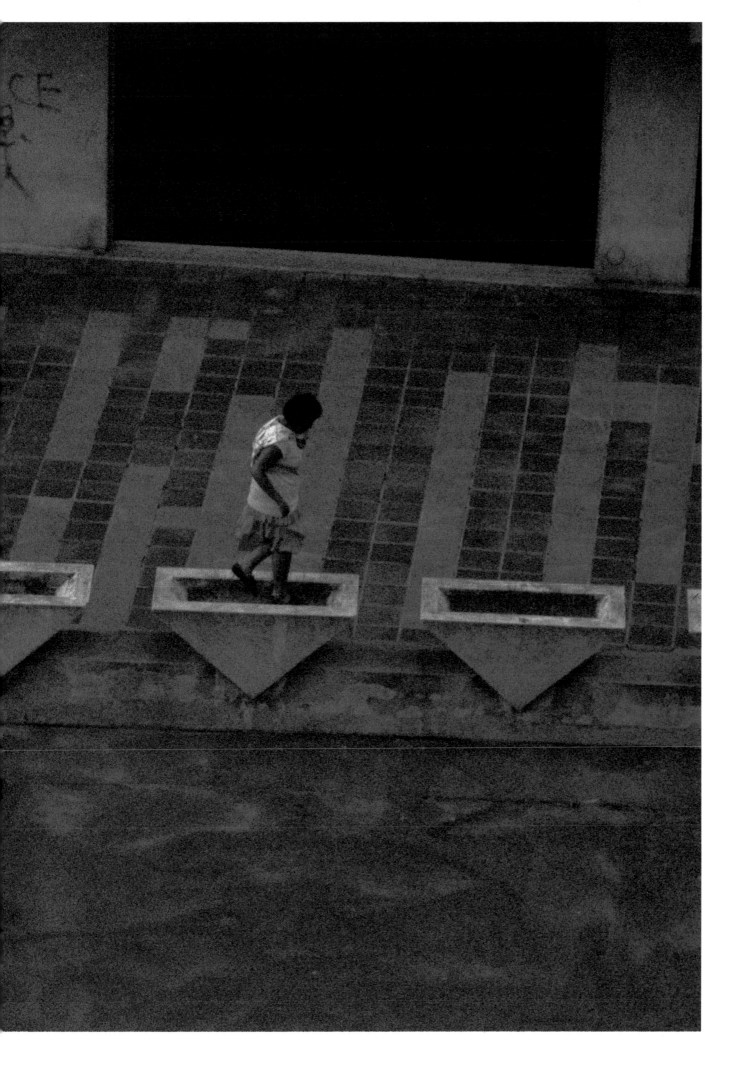

La fille sur
les plots, 1989

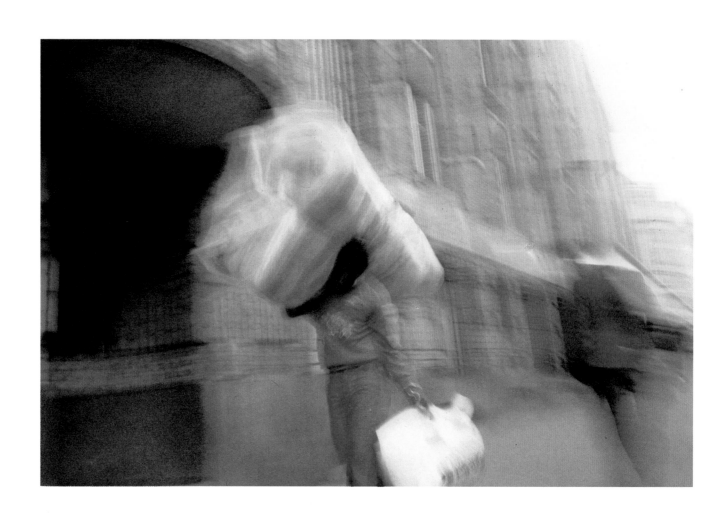

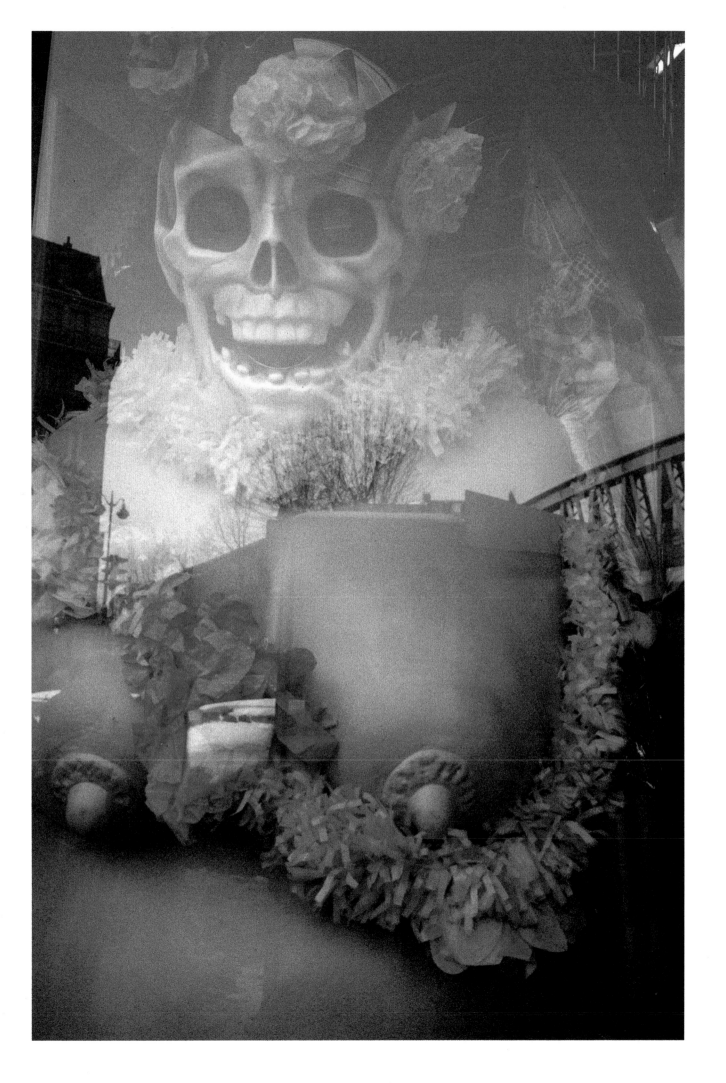

La tête de
mort dans la
vitrine, 1987

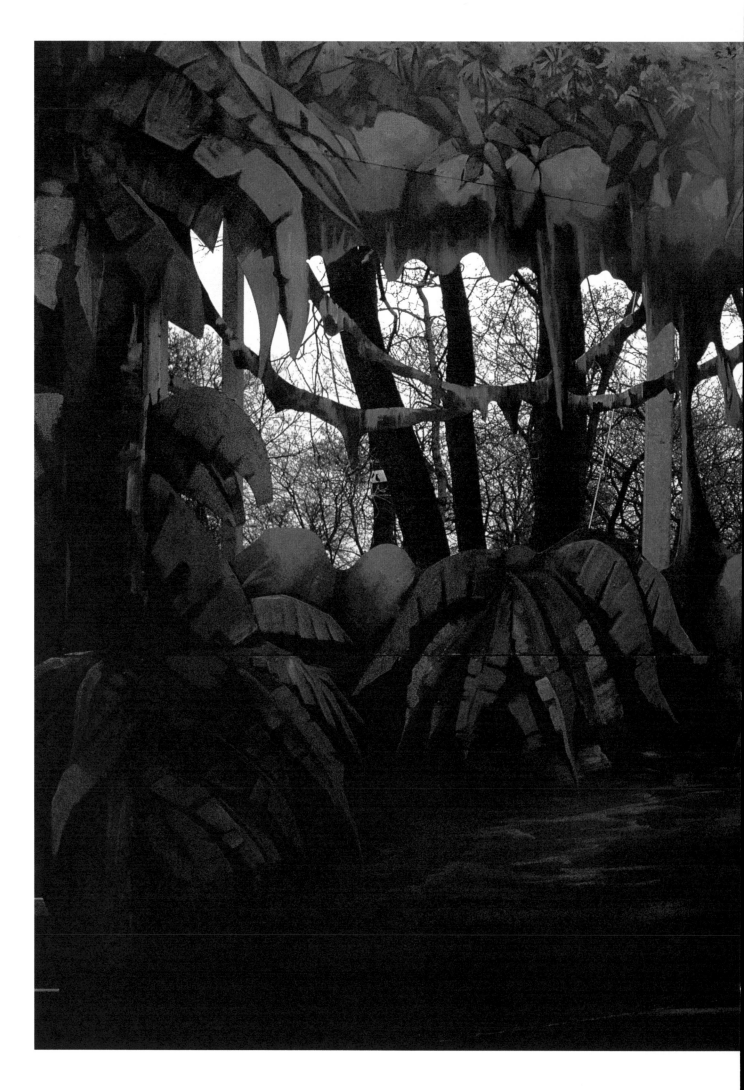

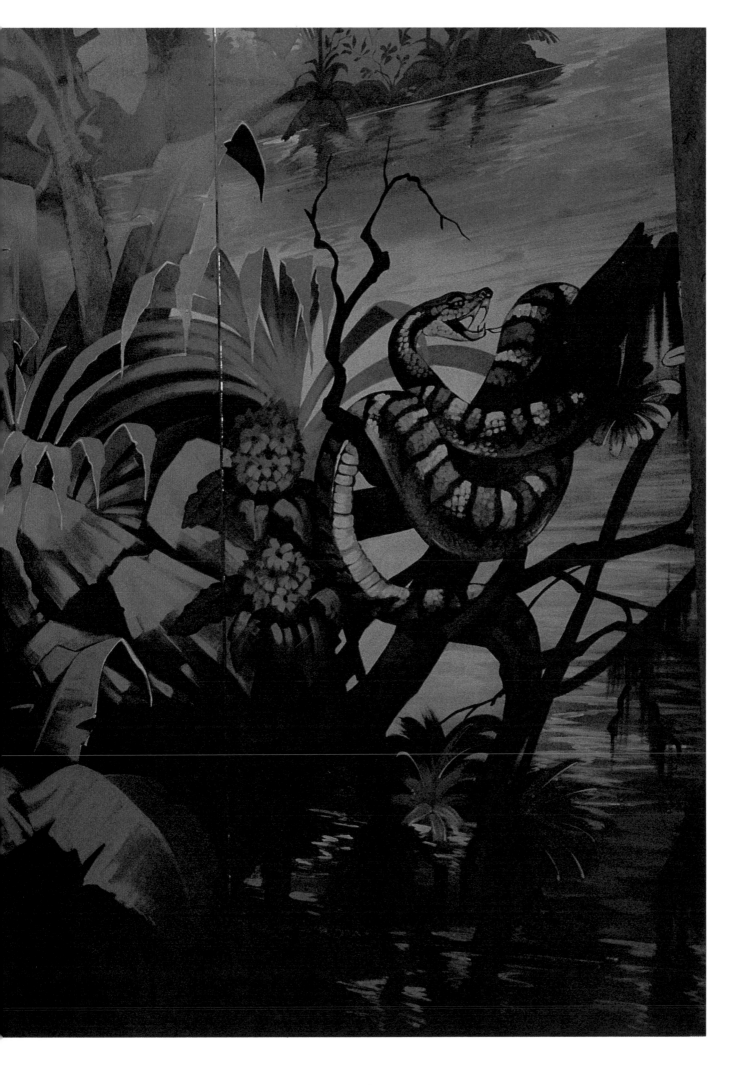

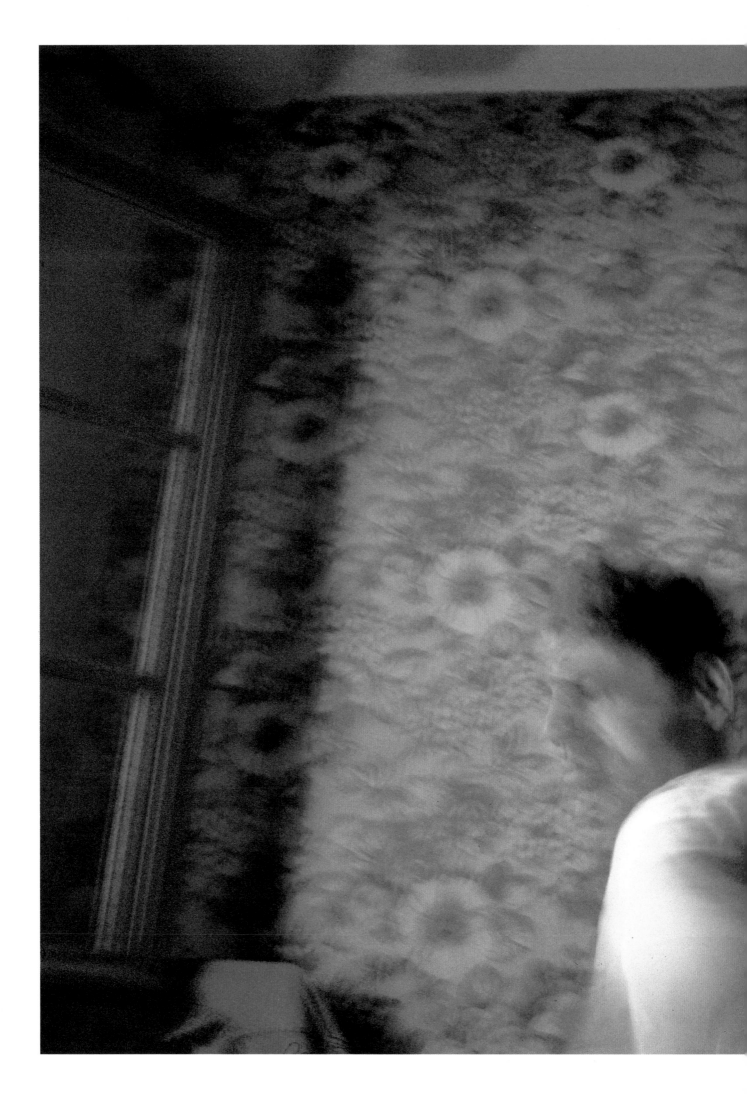

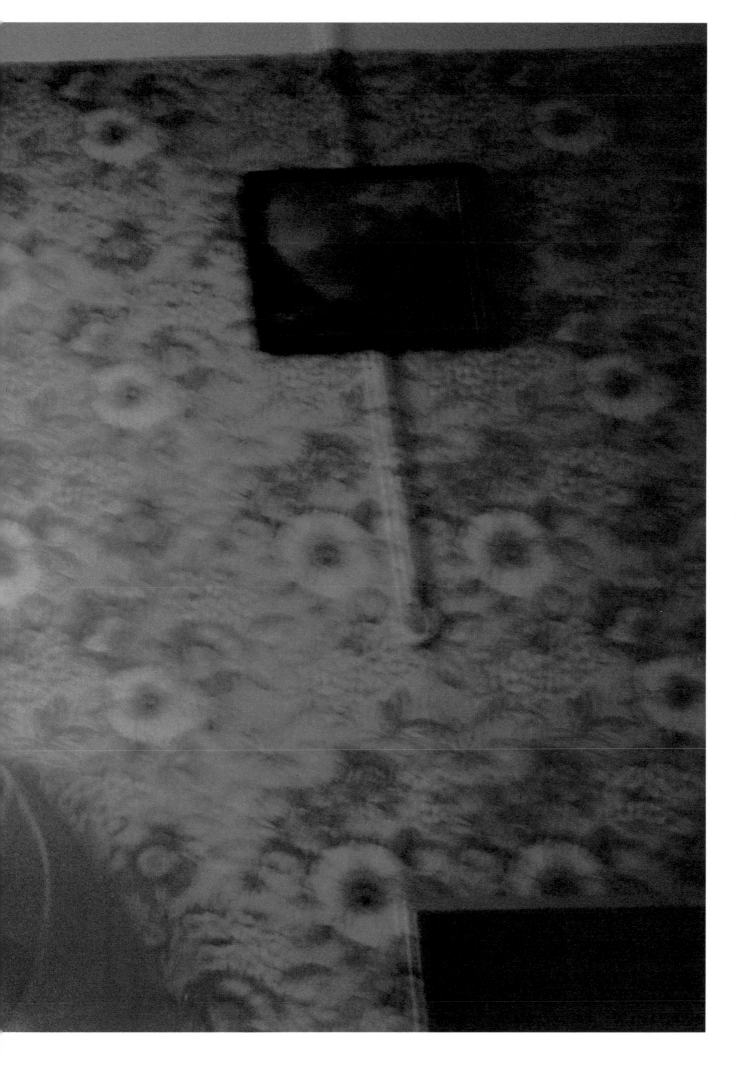

L'homme dans
la chambre
d'hôtel, 1985

75

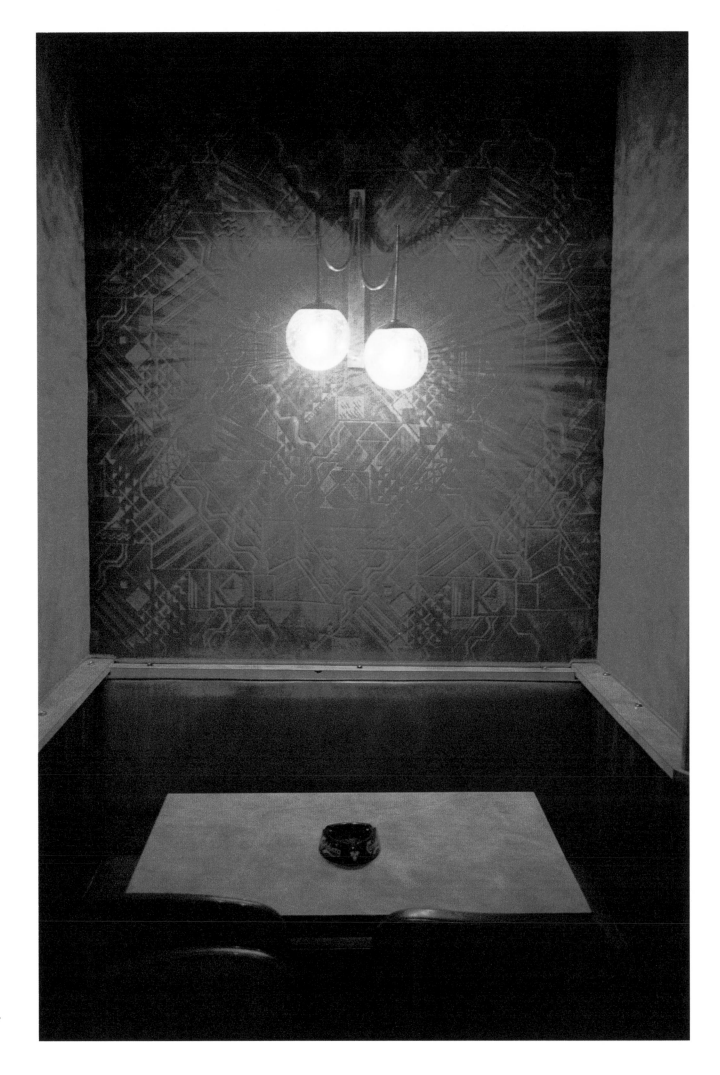

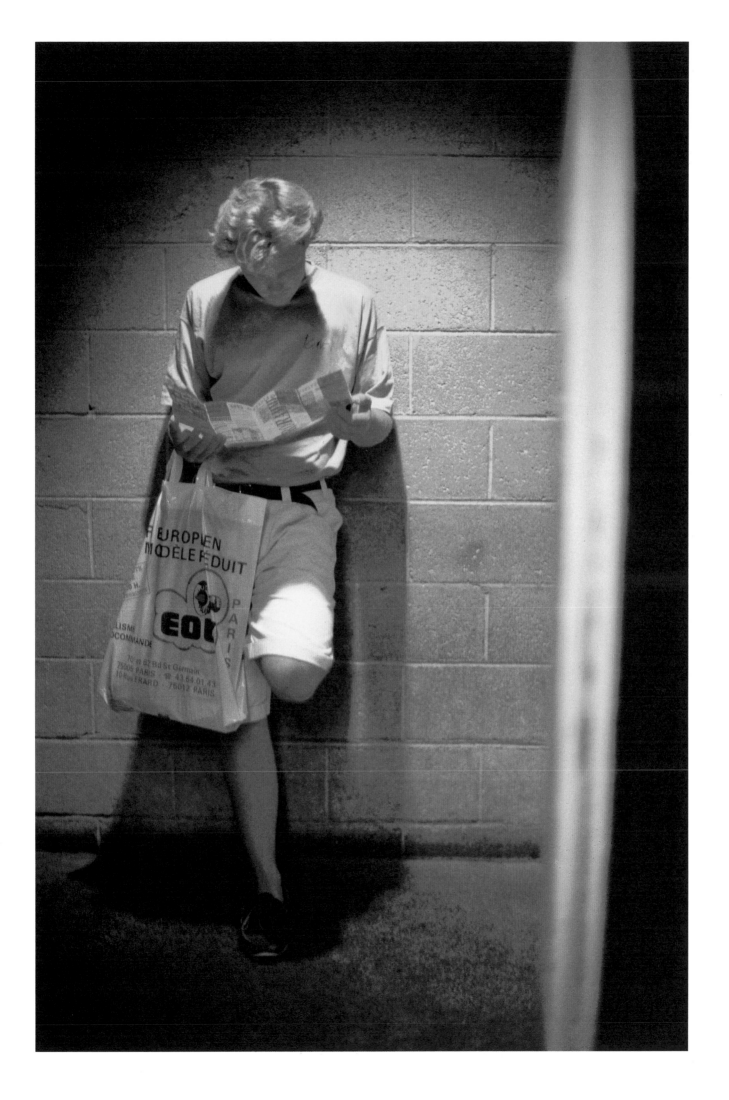

L'homme
qui lit, 1992

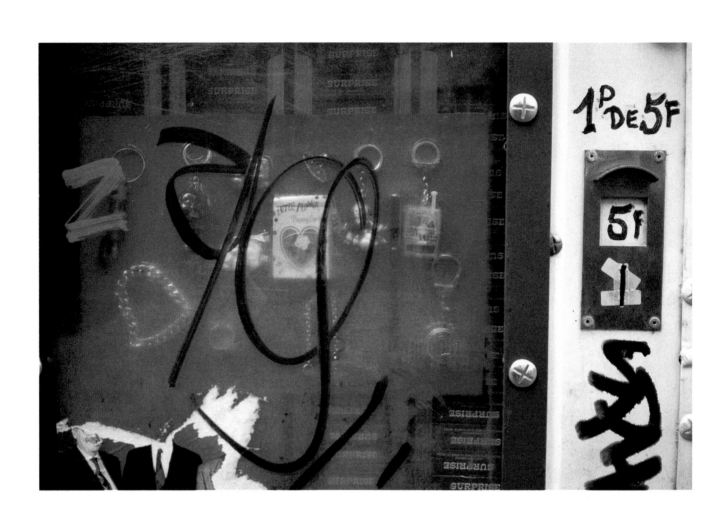

**Le distributeur
de bijoux, 1994**

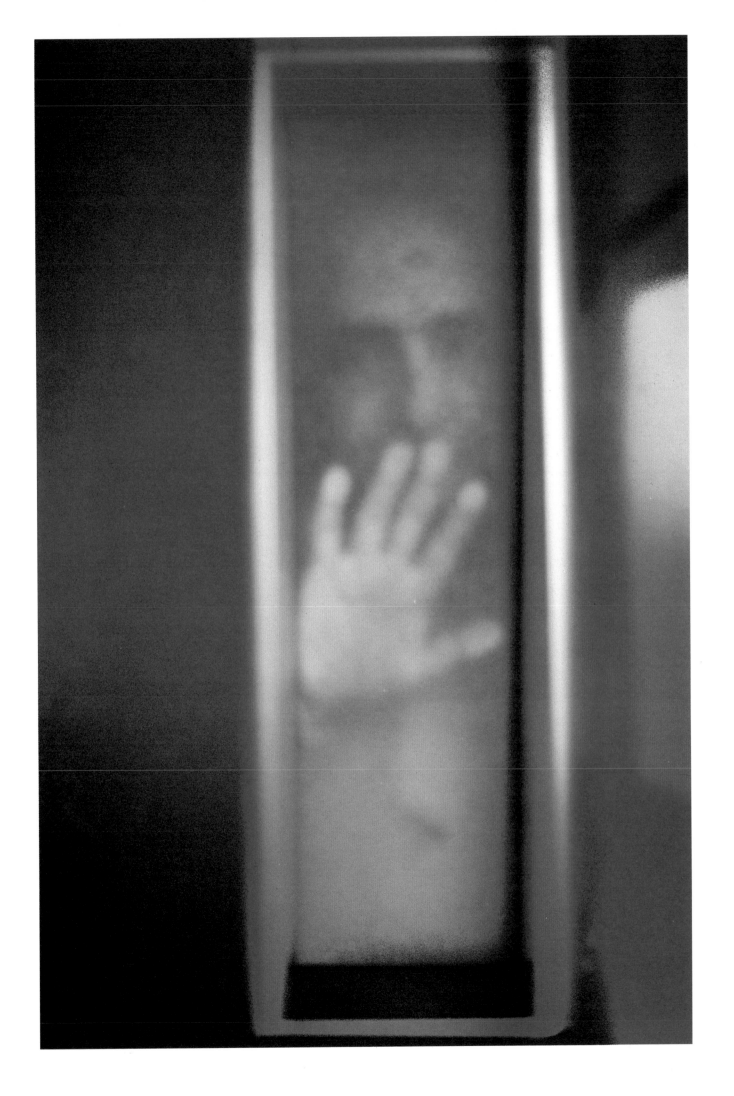

L'homme qui
sort de
l'ascenseur,
1985

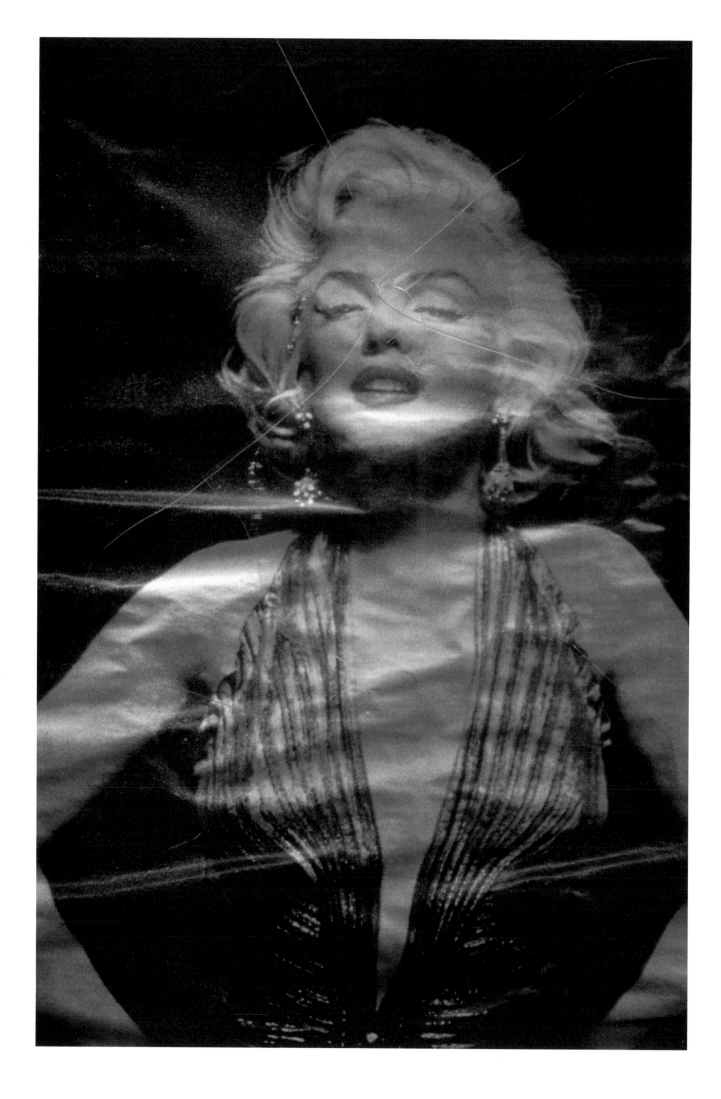

L'affiche de
Marilyn, 1991

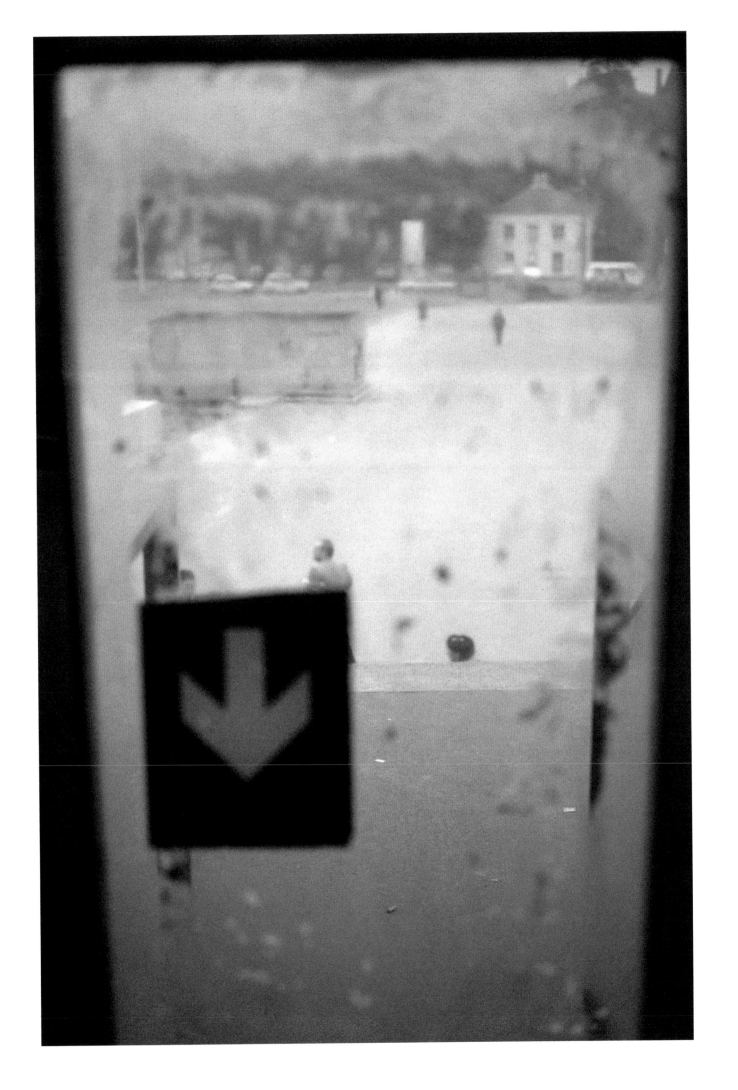

La gare de
Savigny-sur-
Orge, 1985

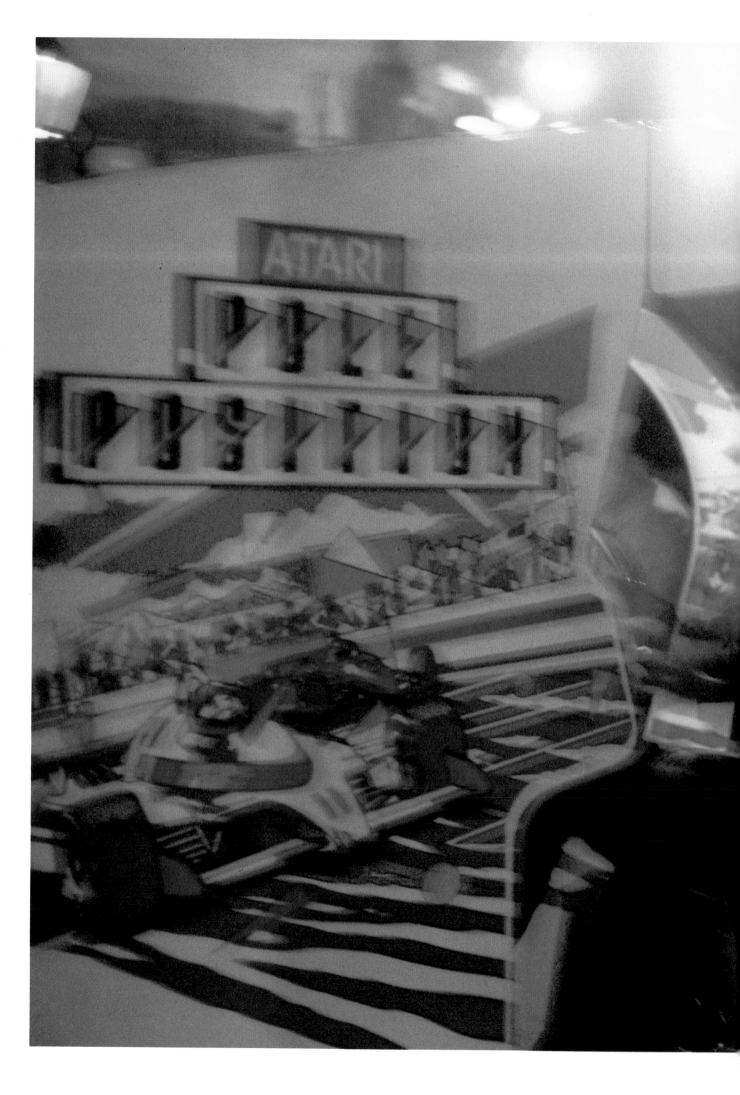

Les deux
garçons au jeu
vidéo, 1985

82

La voiture sous
la bâche, 1992

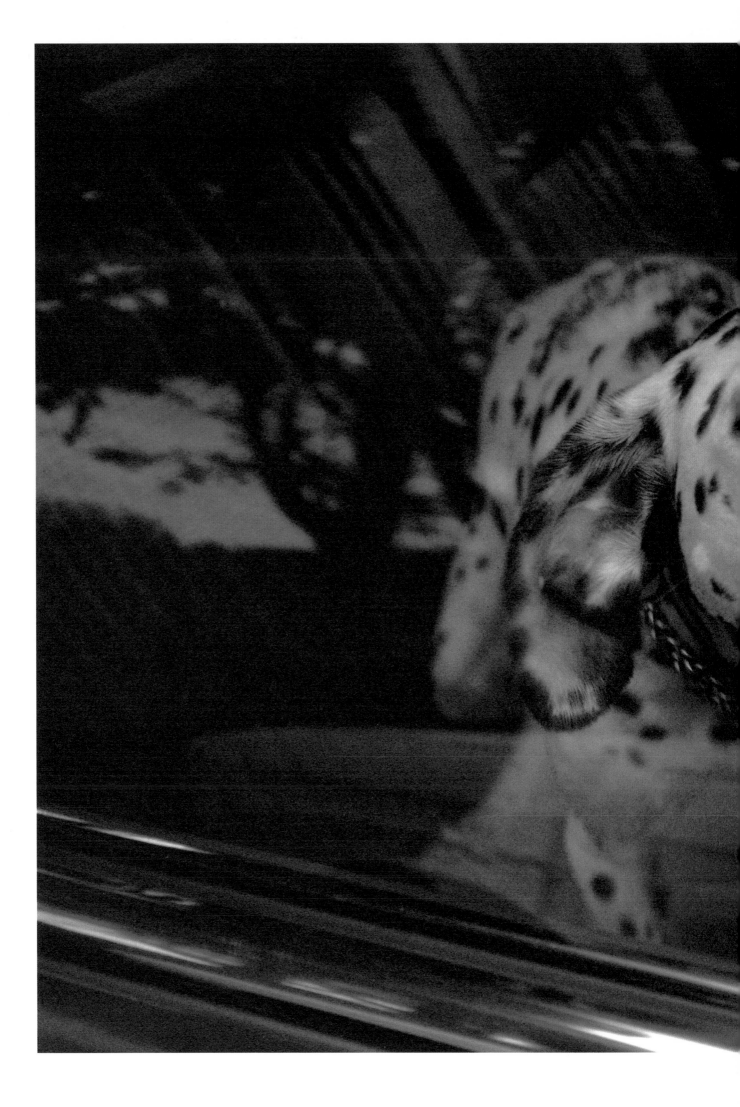

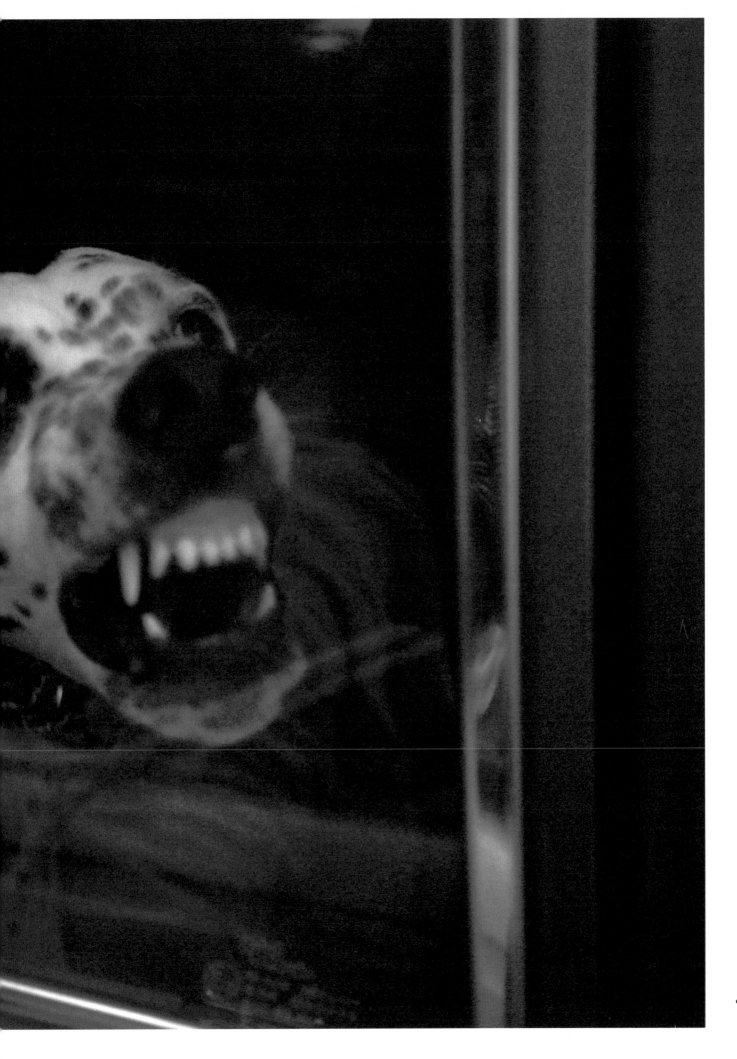

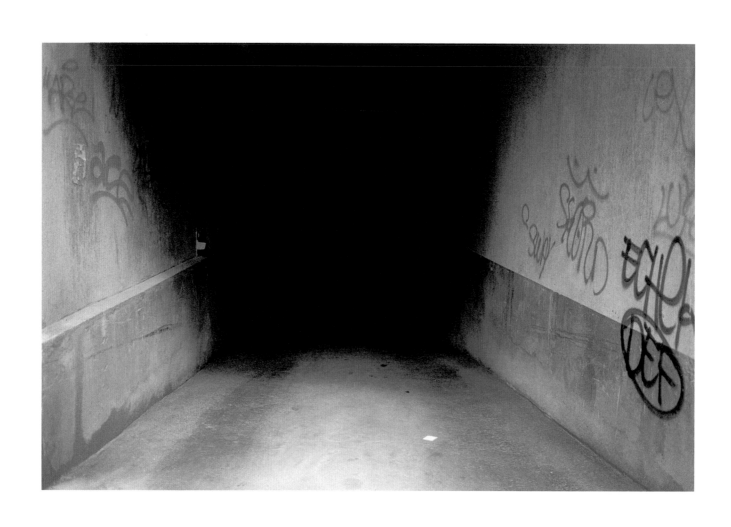

L'entrée du

parking, 1993

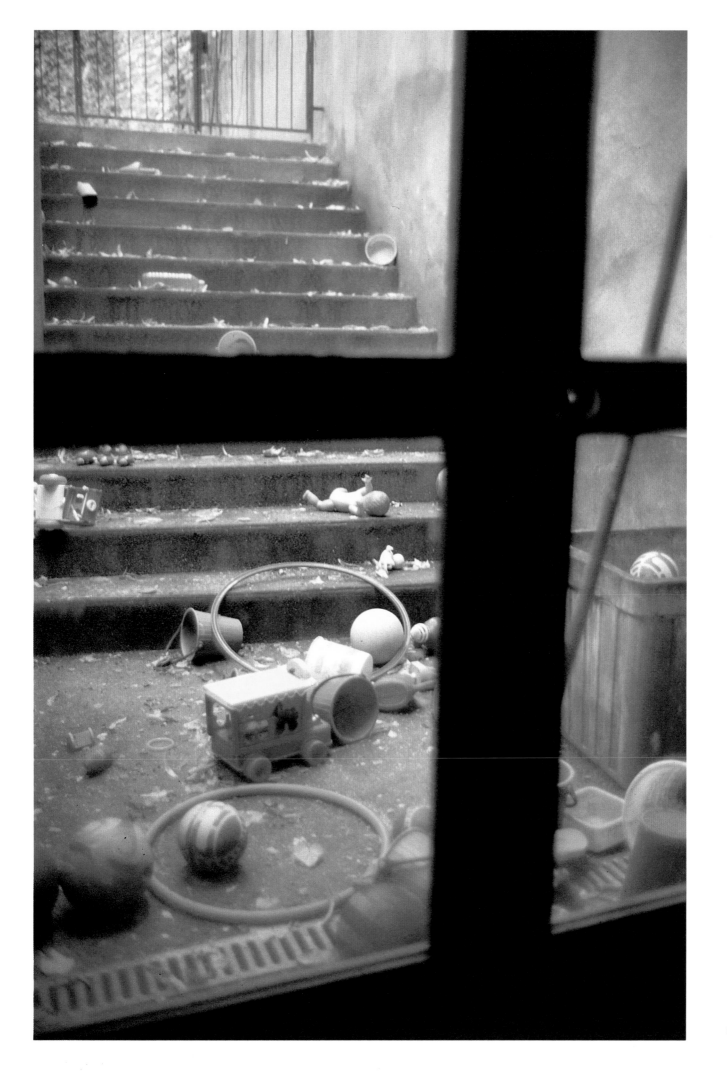

Les jouets
rue des
Martyrs, 1986

86

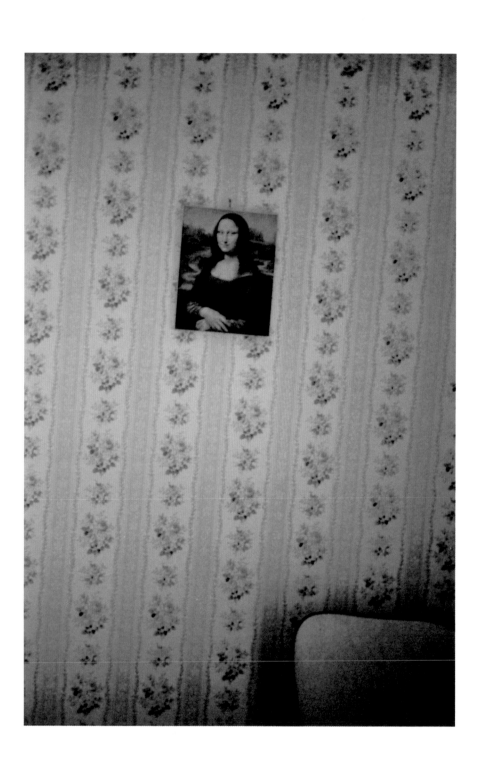

La Joconde de
la chambre
d'hôtel, 1992

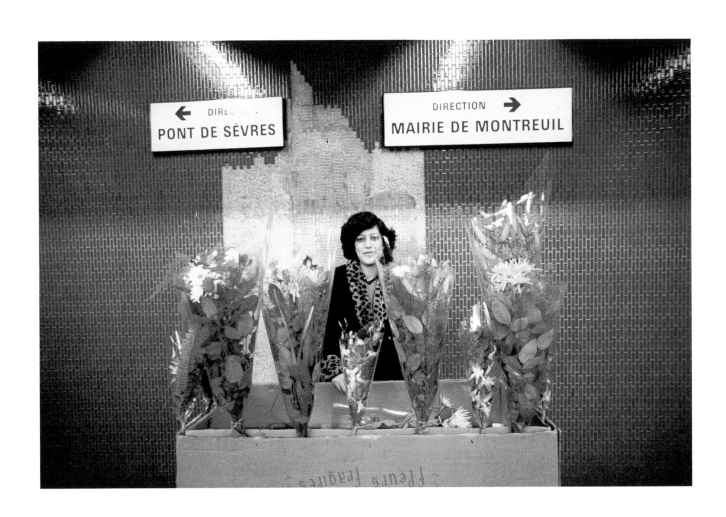

La marchande

de fleurs, 1984

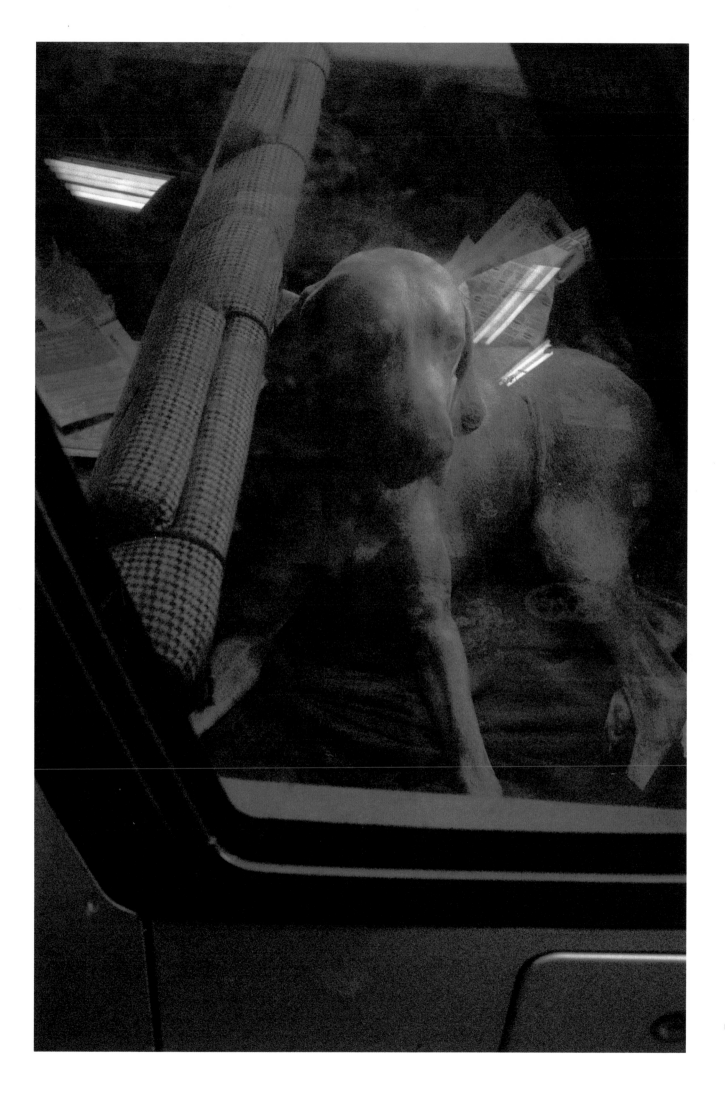

Le chien bleu,
1986

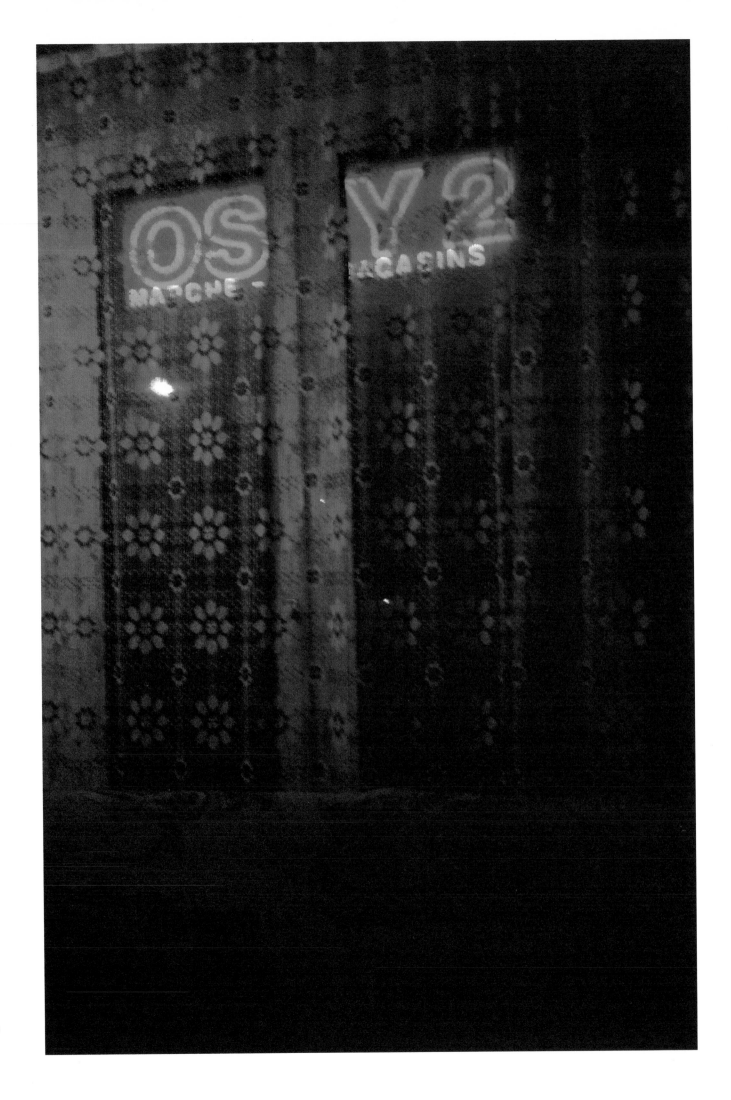

Le rideau du
HLM, 1992

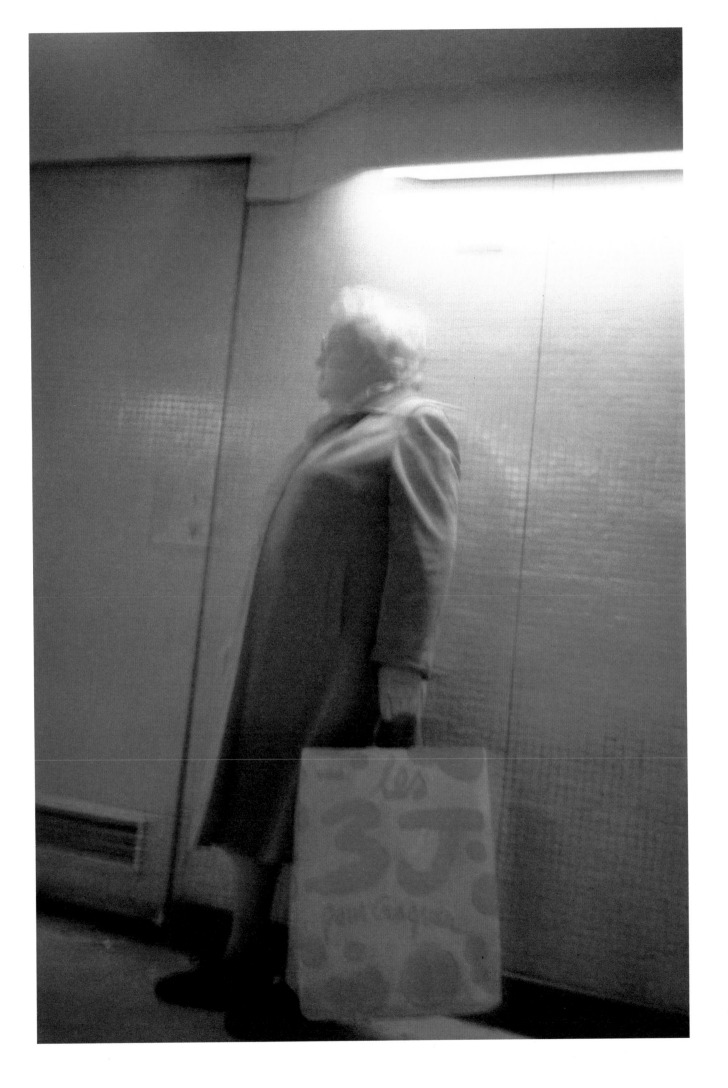

La femme
au sac trois J,
1992

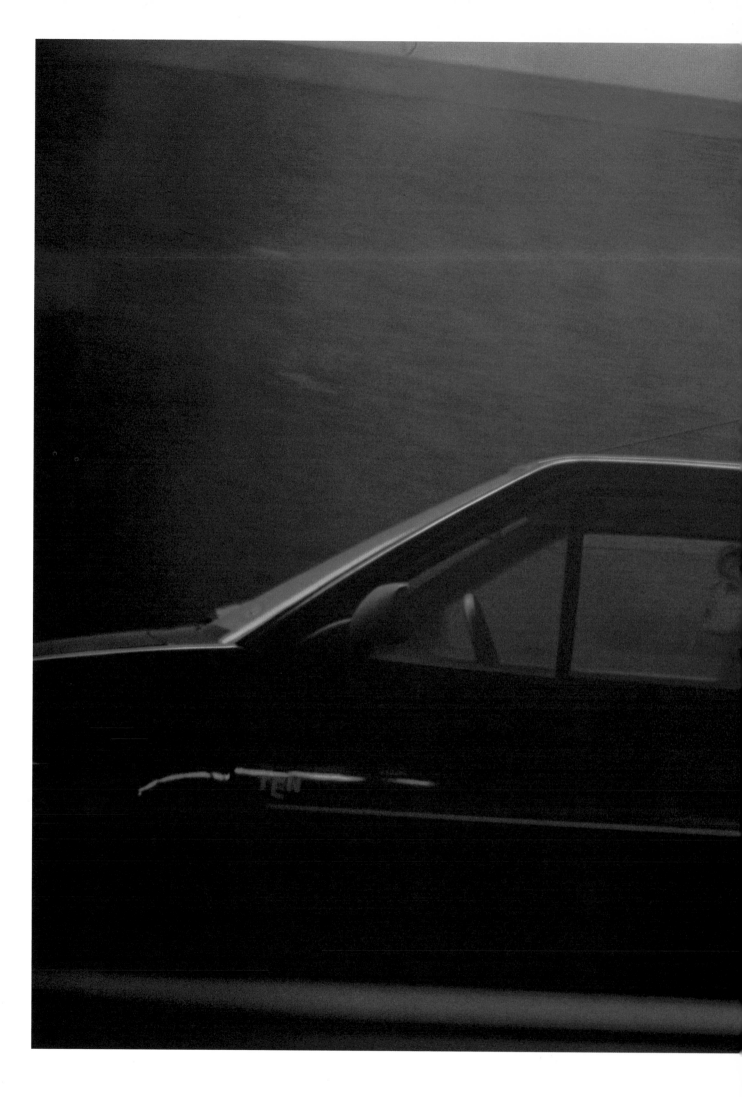

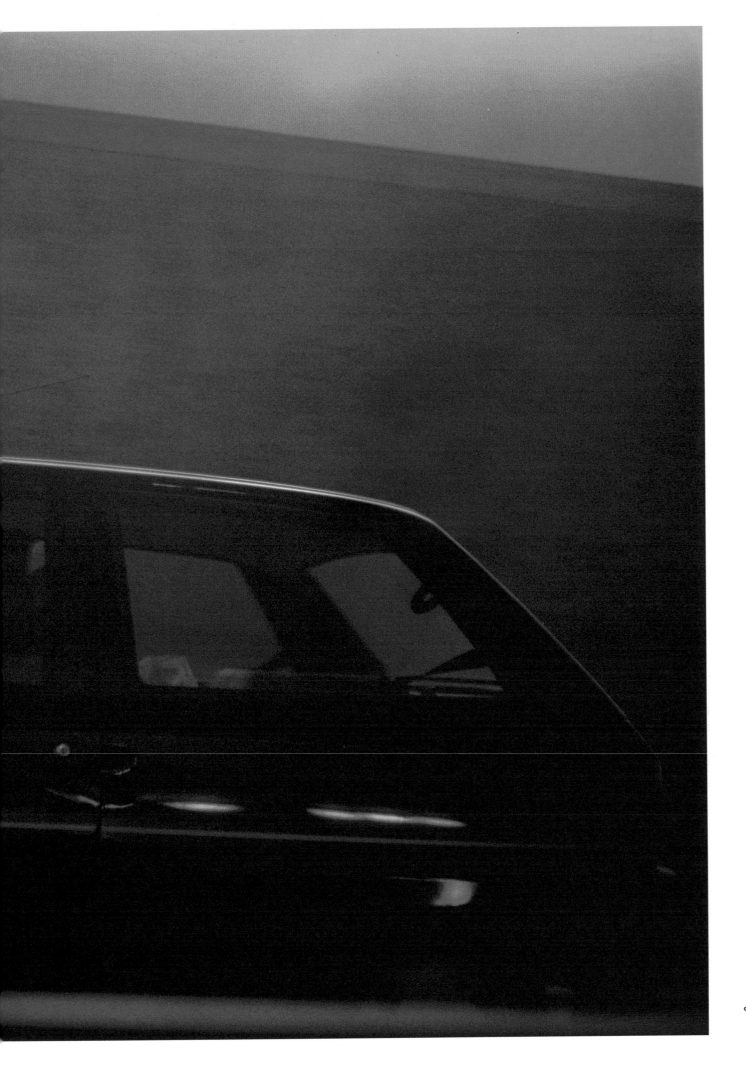

La voiture
dans le tunnel,
1993

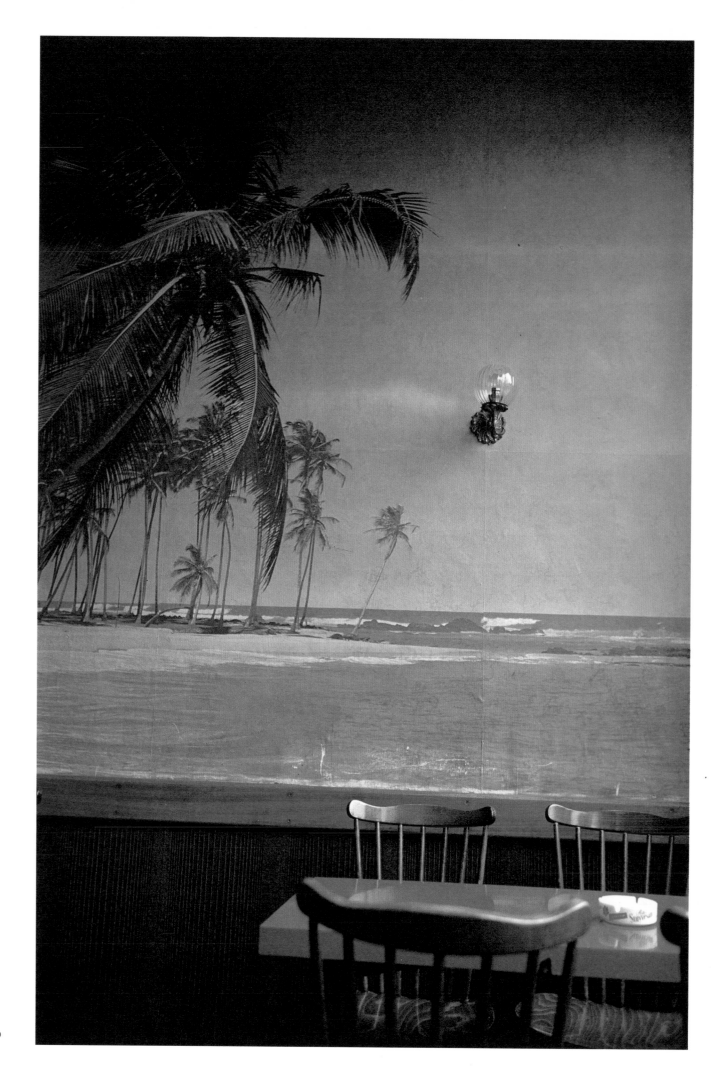

La table du
café des
Goélands, 1990

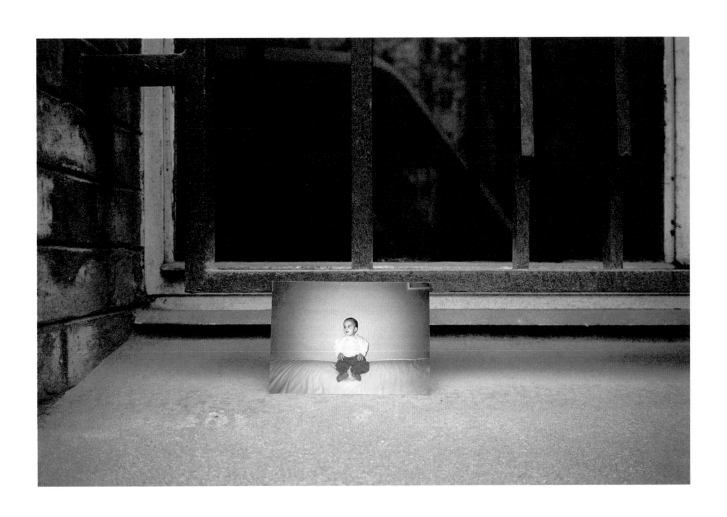

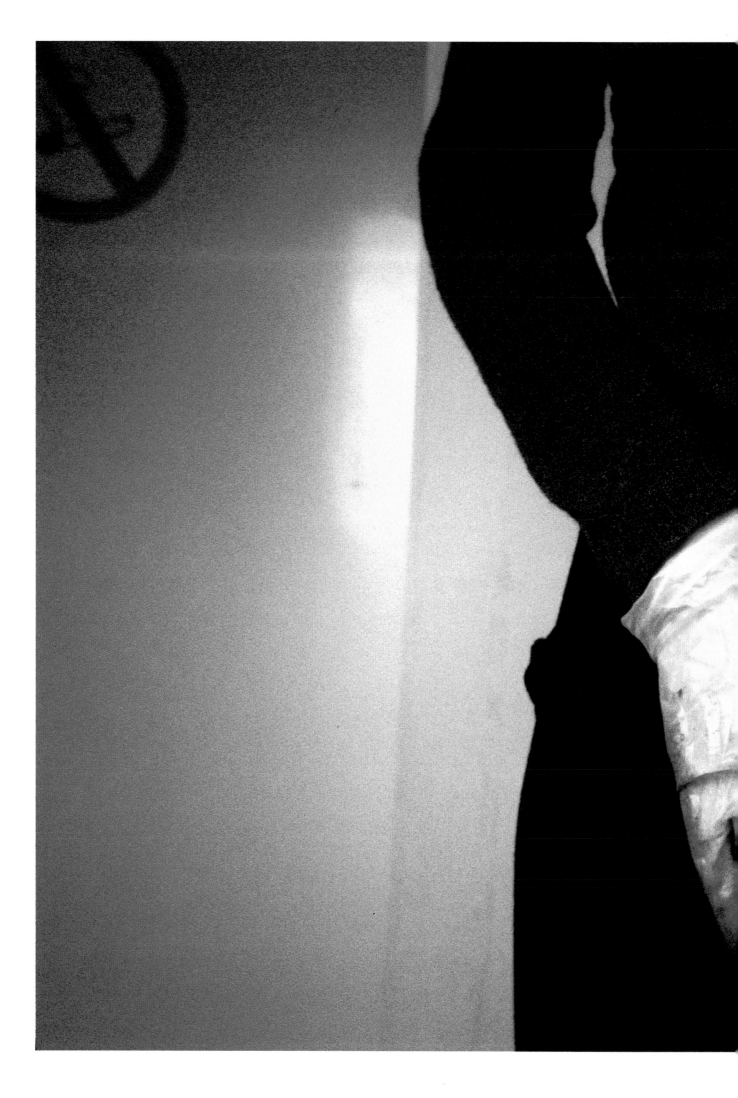

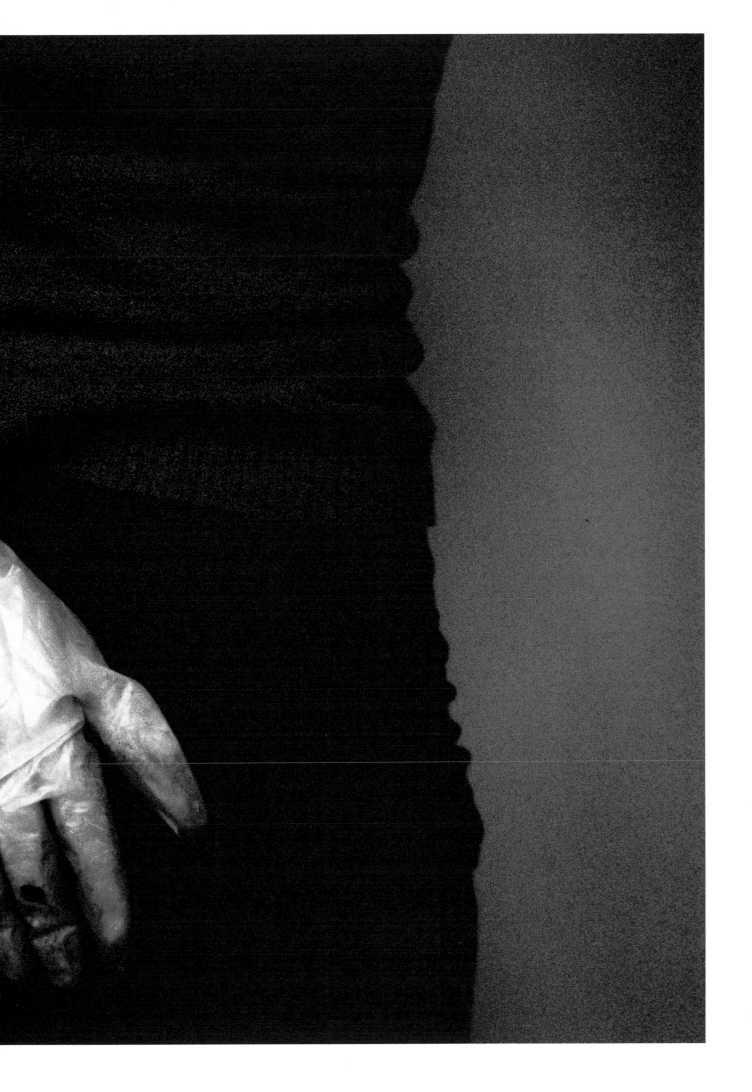

Le gant
transparent,
1994

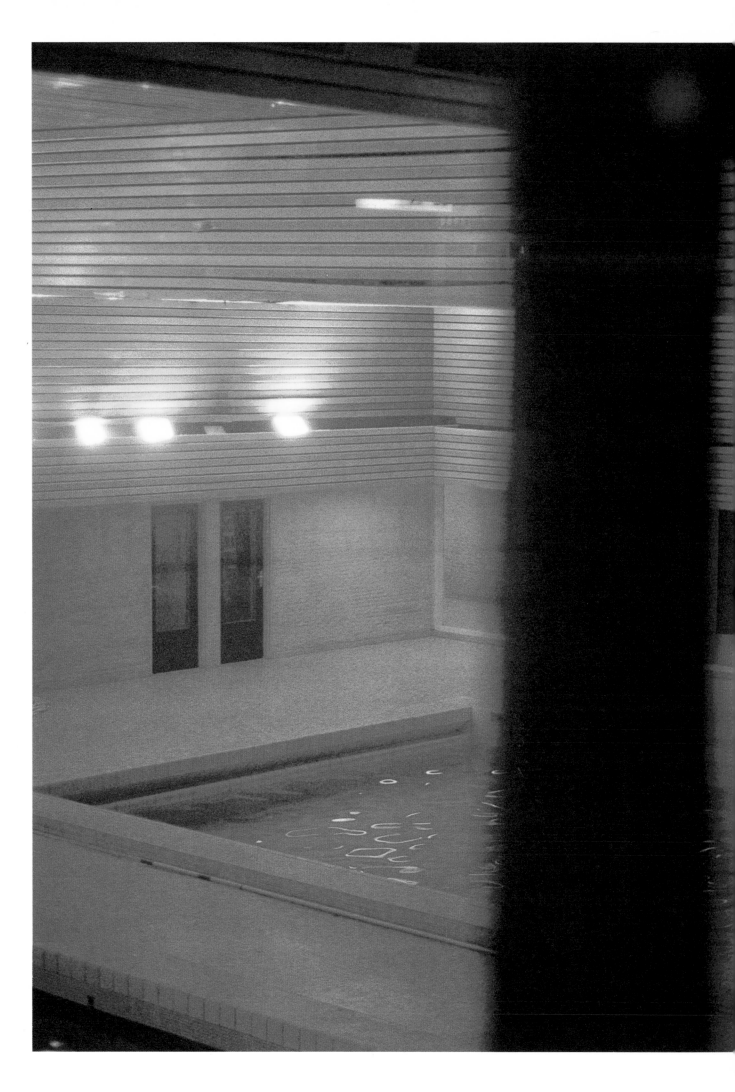

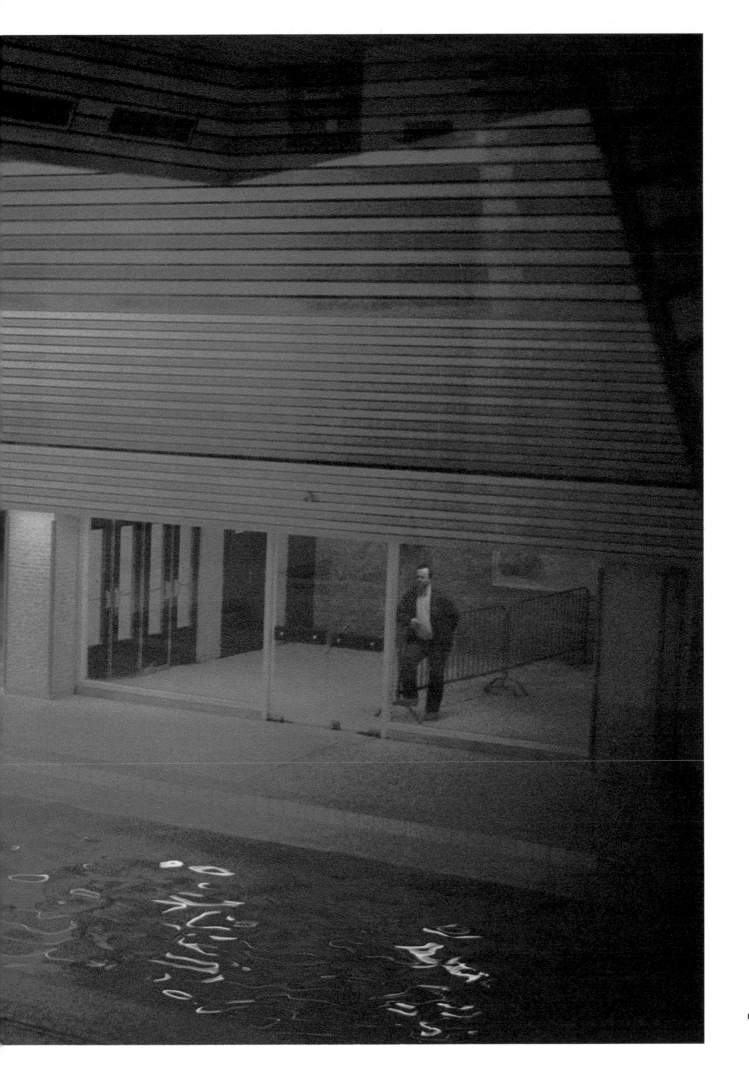

L'homme à la
piscine, 1988

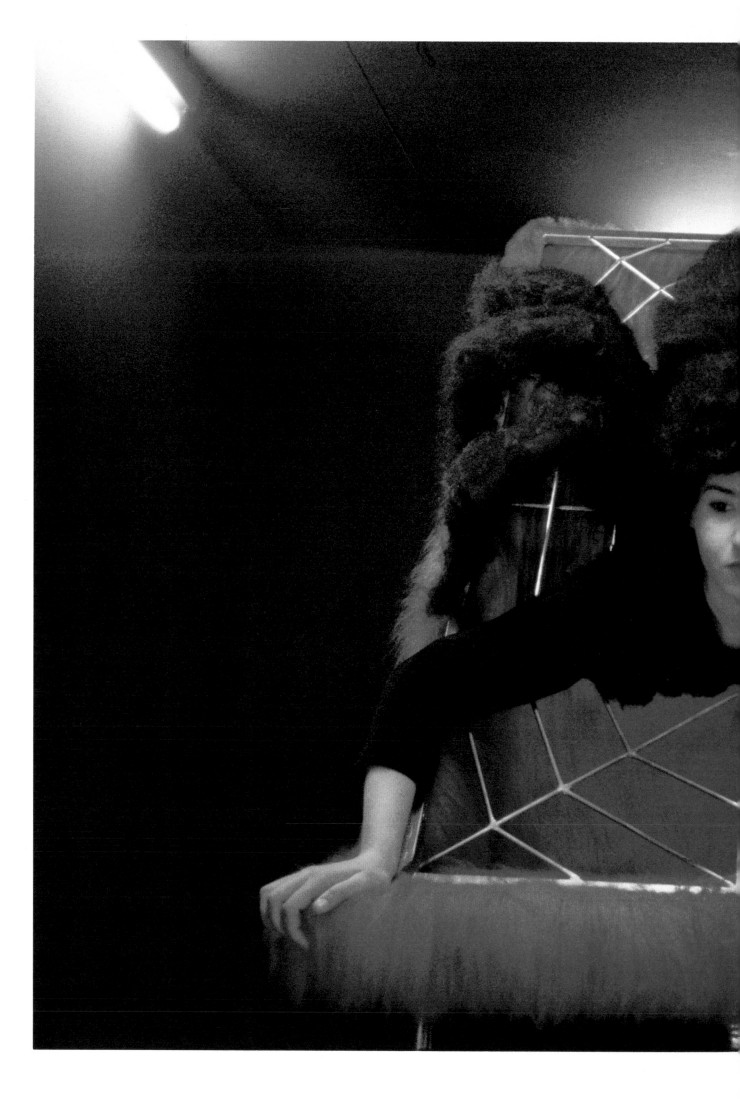

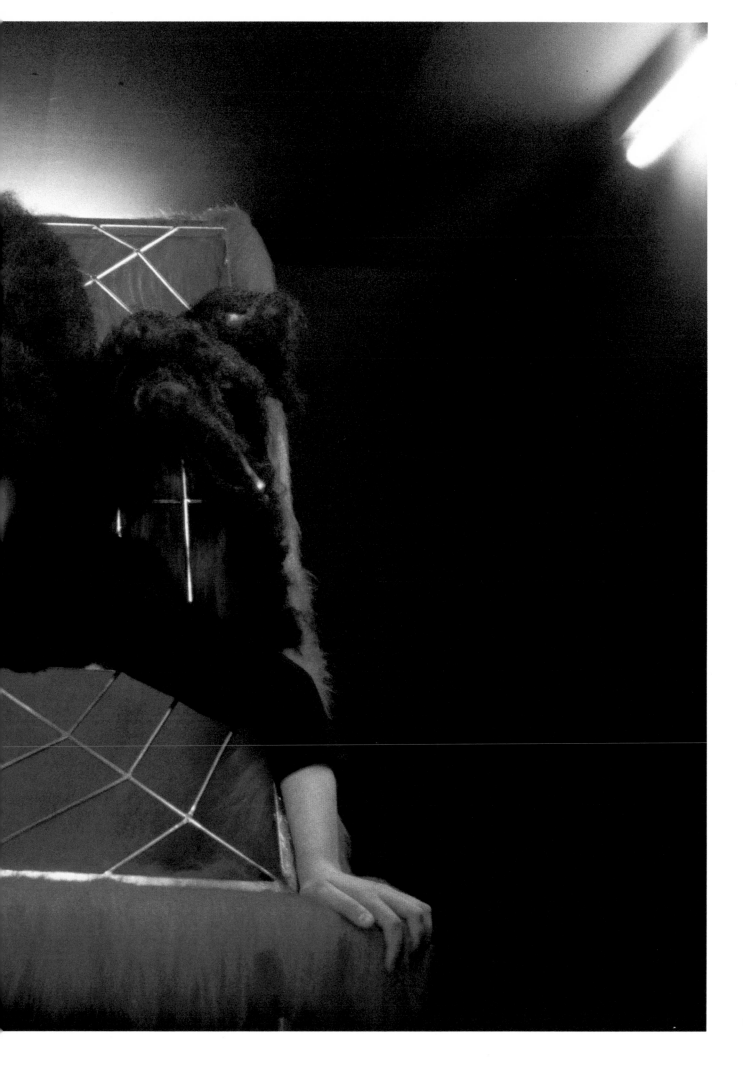

La femme
araignée, 1993

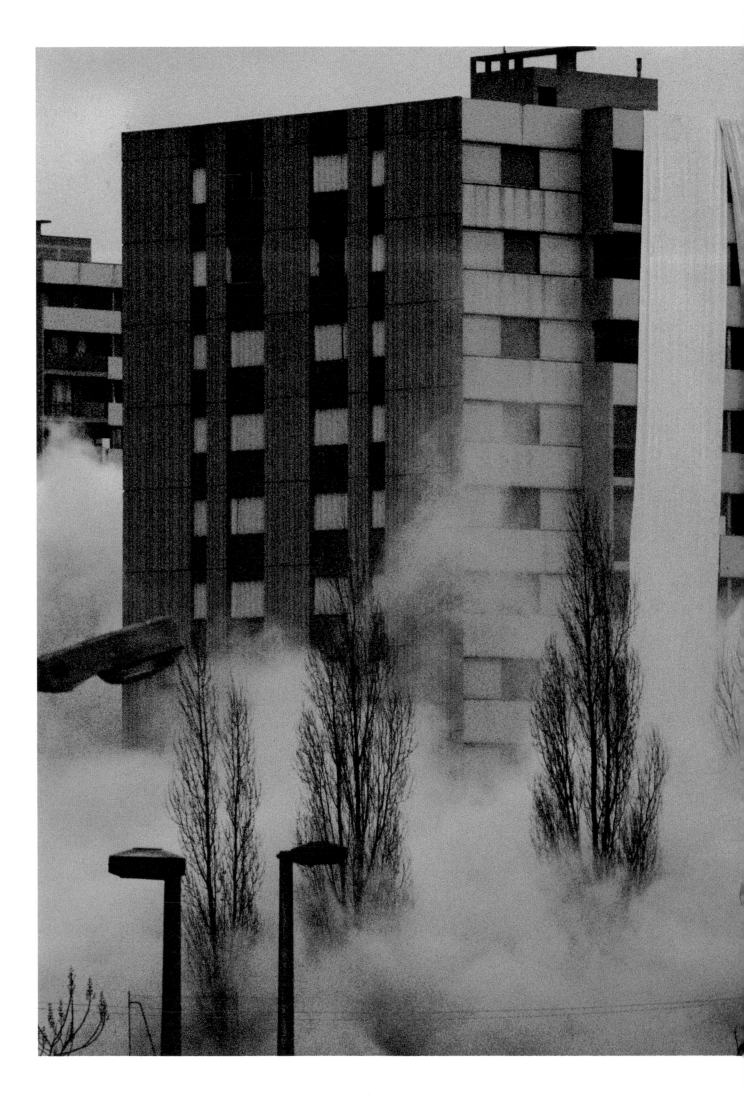

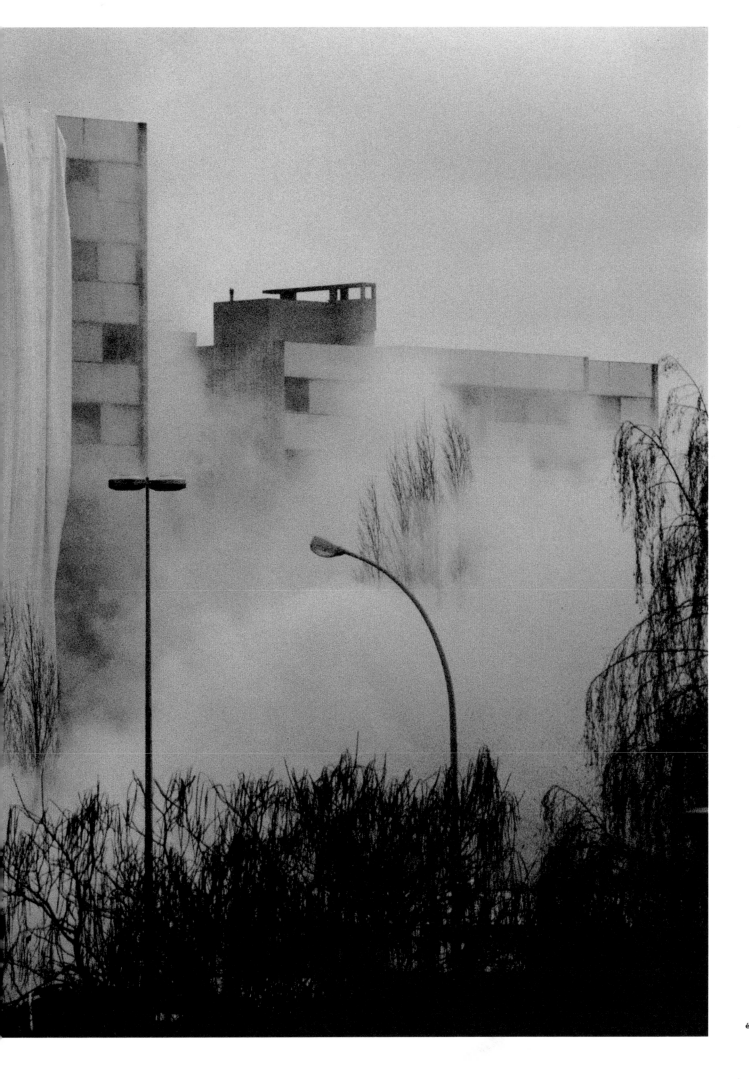

La tour
écroulée, 1993

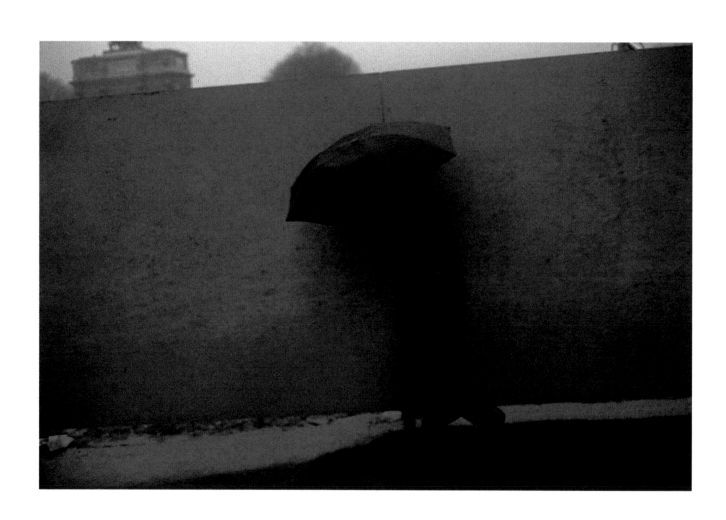

La femme au
parapluie, 1992

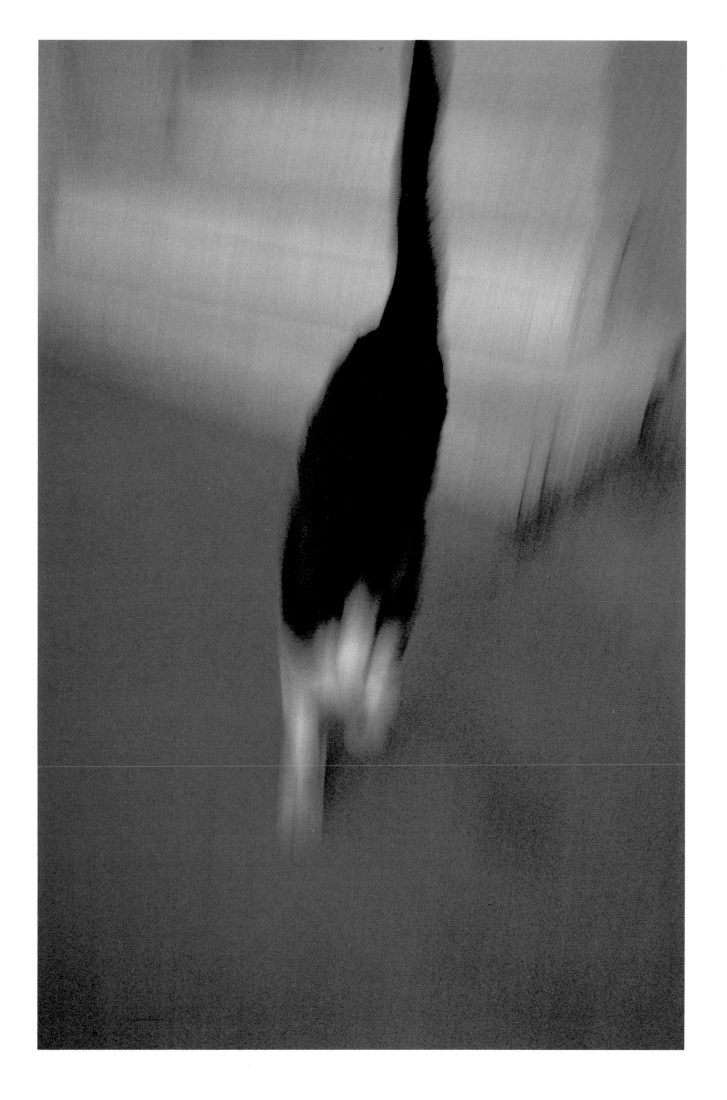

Le chat qui
s'en va, 1987

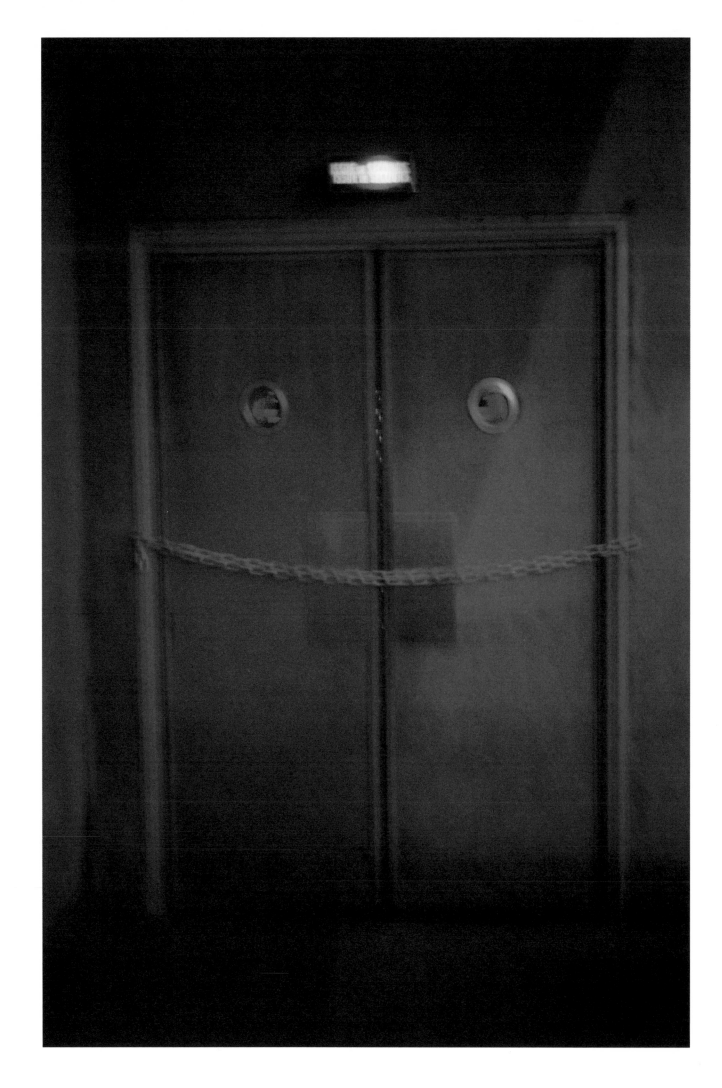

La porte du
cinéma, 1993

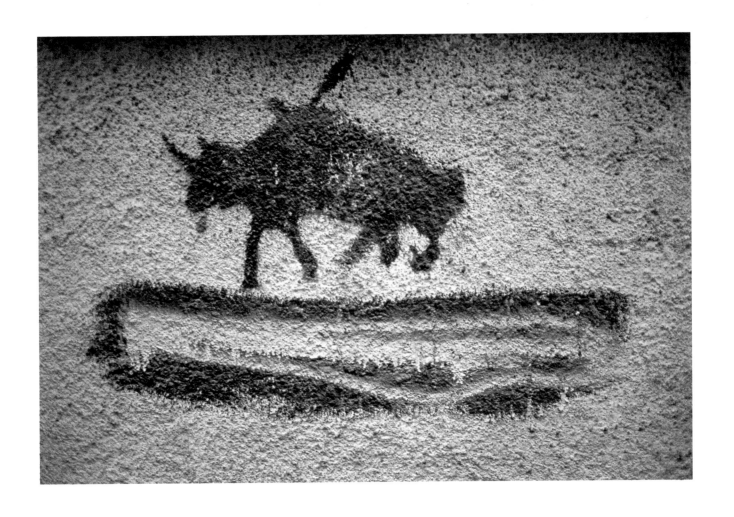

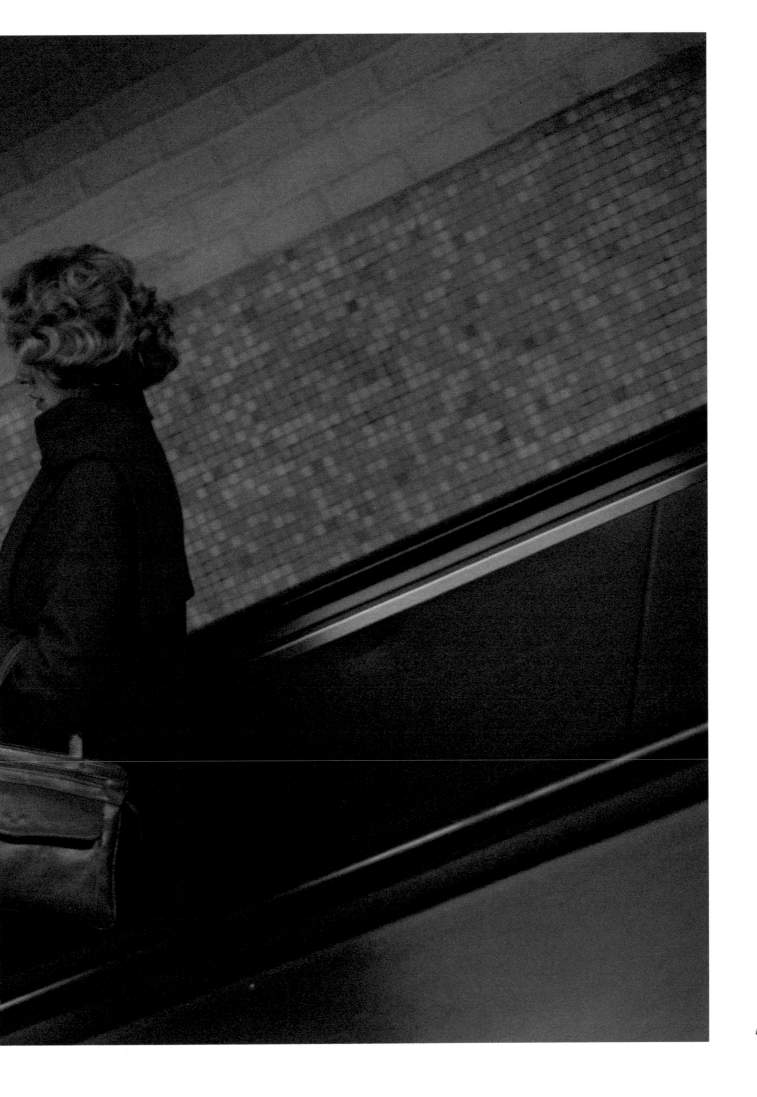

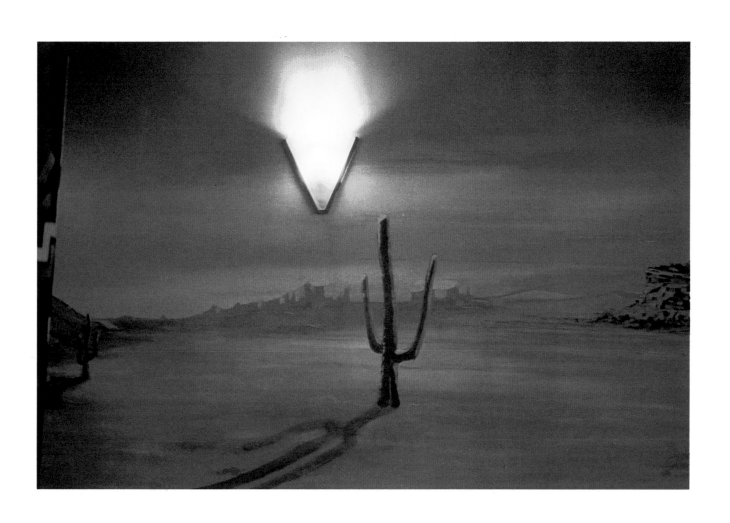

Français

English

First English Edition published

in the United Kingdom in 1995

by Dewi Lewis Publishing

8 Broomfield Road

Heaton Moor

Stockport SK4 4ND

0161 442 9450

ISBN: 1-899235-15-9

British Library Cataloguing-in-Publication Data

A Catalogue record for this book is available

from the British Library

Translation : Alison Hirst

Design : Francis Dumas

Photogravure : Sele Offset Torino, Turin

Print : Musumeci, Aoste

Printed in August 1995

PRINTED AND BOUND IN ITALY